Mandala me Happy
Mindfulness through Coloring

by Autumn Craig

www.create-simple-abundance.com

Introduction

Mandalas originated in Asia and are often used in Hindu and Buddhist art. The word mandala in Sanskrit means circle and they offer balancing visual elements symbolizing unity and harmony. Many people use mandalas as a meditative tool either by using them as a visual aid or by drawing them. You can now do something similar as a way to calm your mind similar to meditation by coloring them and allowing your creative mind to come out. Not to mention coloring in general is a fun and relaxing activity. You can color using any medium you like from colored pencils, to markers to pastels. It is always good to put a blank piece of heavy paper or wax paper between the page you are working on and the next page to prevent any bleed through.

Select one now that appeals to you and color as you like. If you wish, you can set an intention before you begin, for example, "As I color this mandala my stress levels will decrease" or "As I color this mandala I will learn something about myself". There are no wrong answers and it is perfectly fine to just color them and not worry about setting an intention at all.

The information in this book is not intended or implied to be a substitute for professional medical advice, diagnosis or treatment. All content, including text, graphics, images and information, contained on or available through this book are for general information purposes only. NEVER DISREGARD PROFESSIONAL MEDICAL ADVICE OR DELAY SEEKING MEDICAL TREATMENT BECAUSE OF SOMETHING YOU HAVE READ IN THIS BOOK.

<div align="center">

Copyright 2017 - All Rights Reserved – Autumn Craig

www.create-simple-abundance.com
facebook.com/createsimpleabundance/

</div>

ALL RIGHTS RESERVED. No part of this publication may be reproduced or transmitted in any form whatsoever, electronic, or mechanical, including photocopying, recording, or by any informational storage or retrieval system without express written, dated and signed permission from the author.

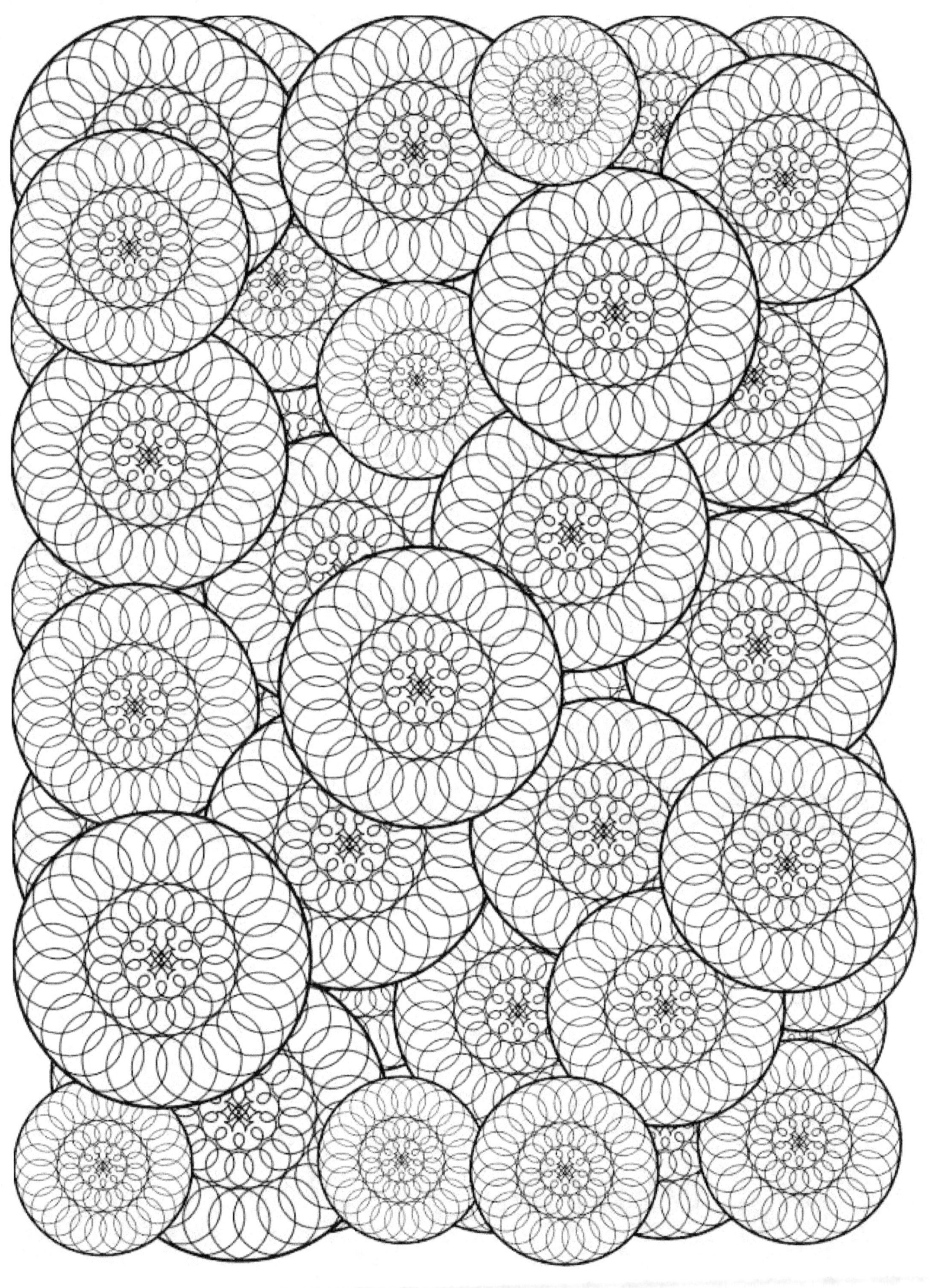

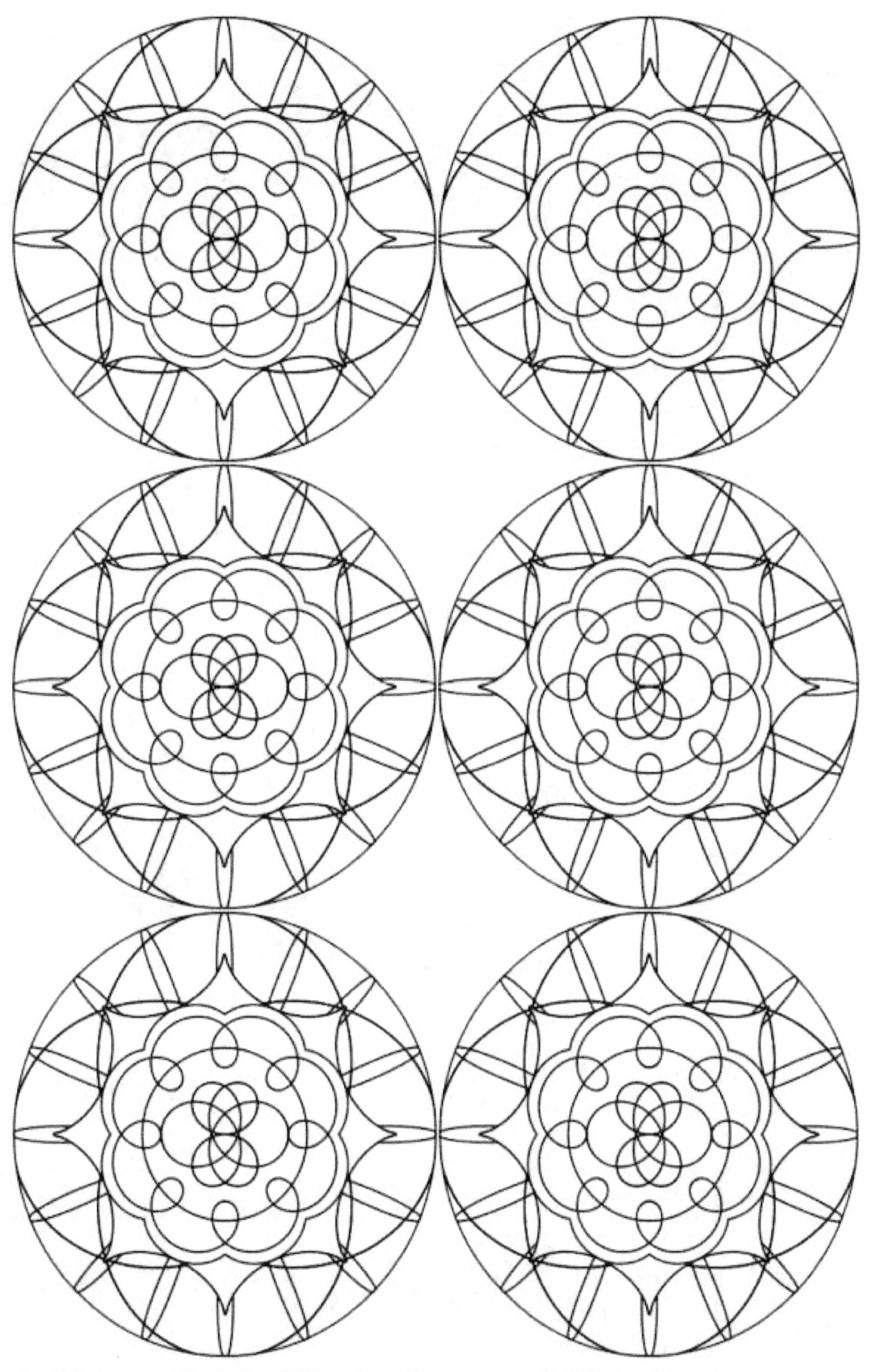

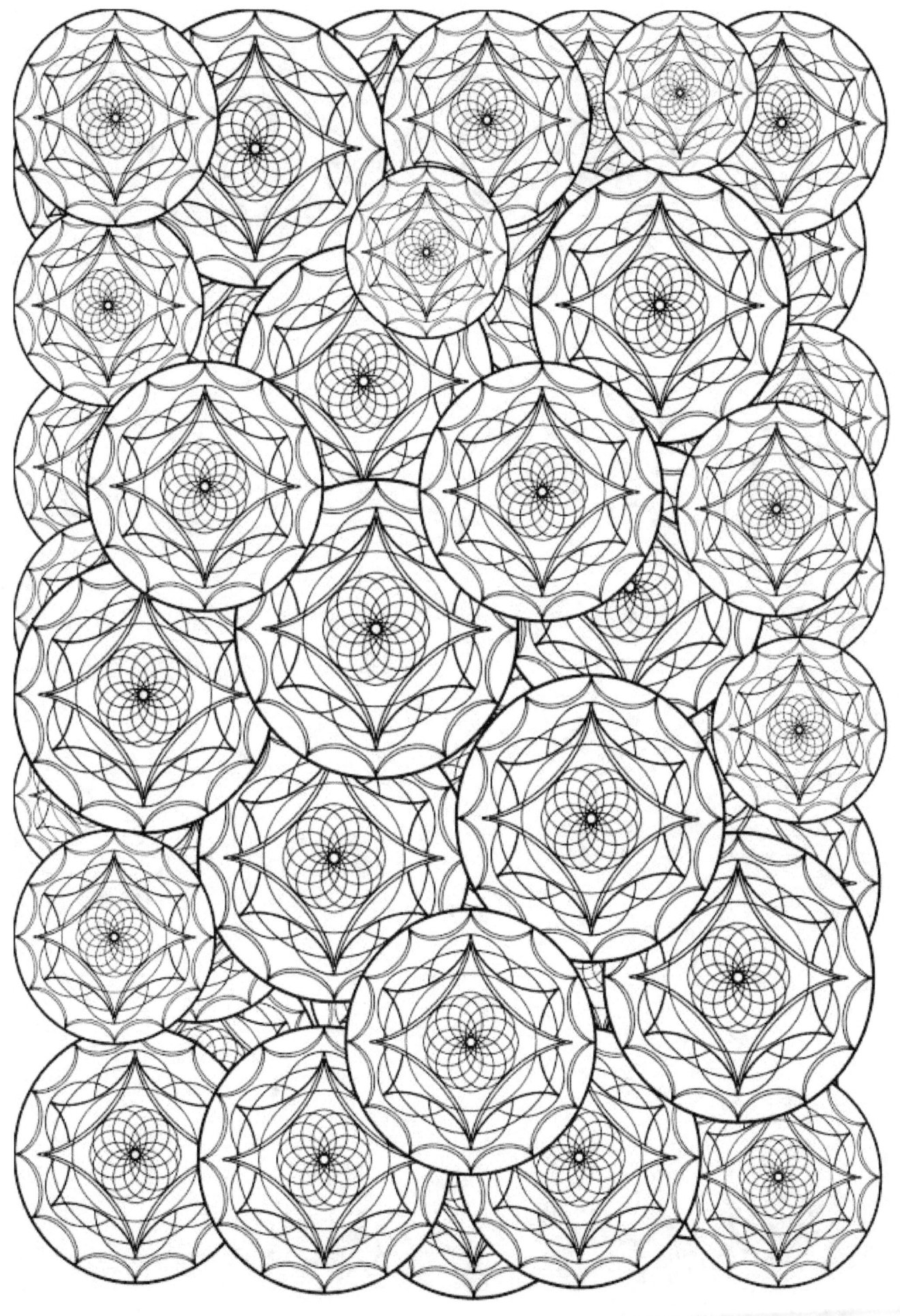

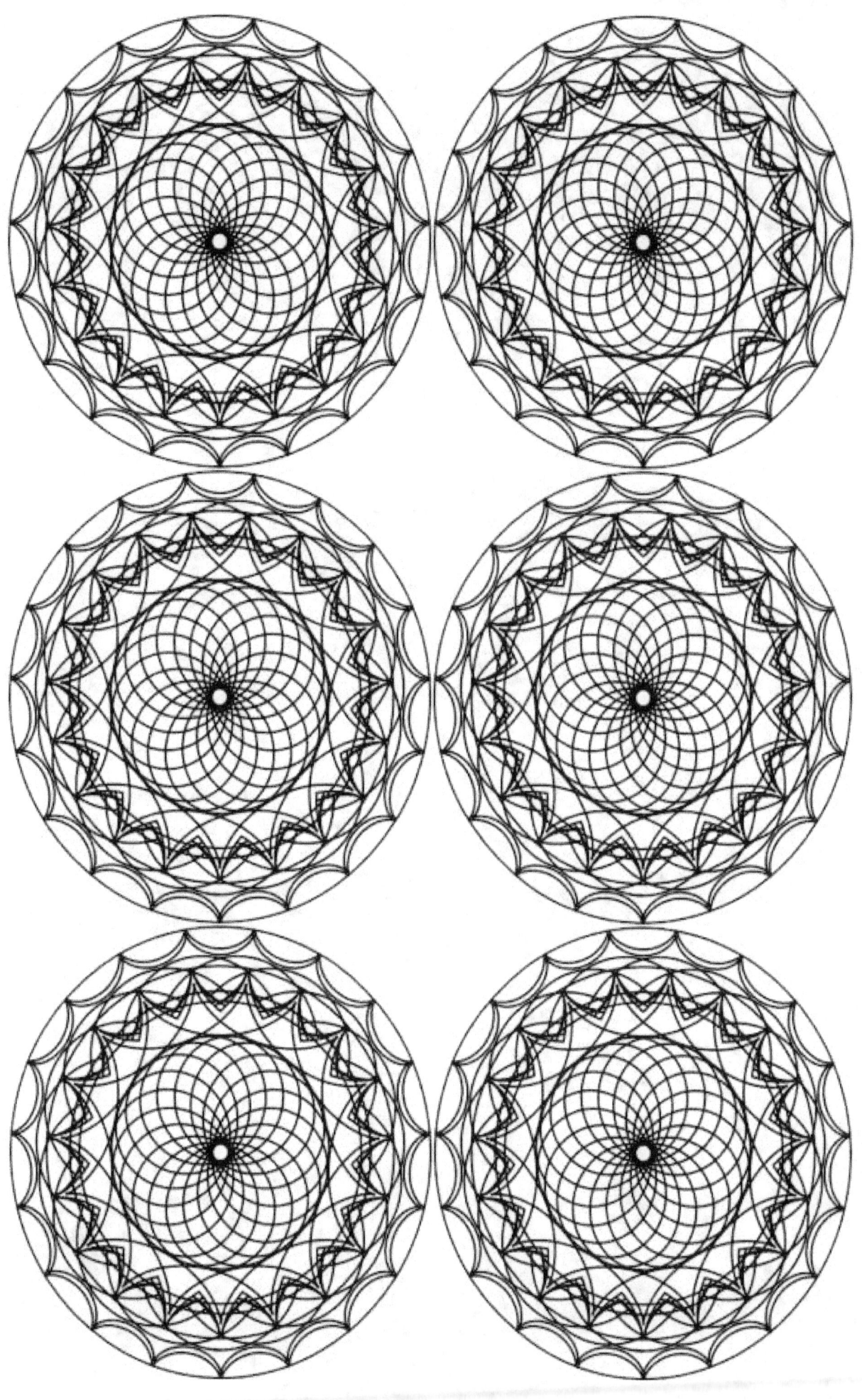

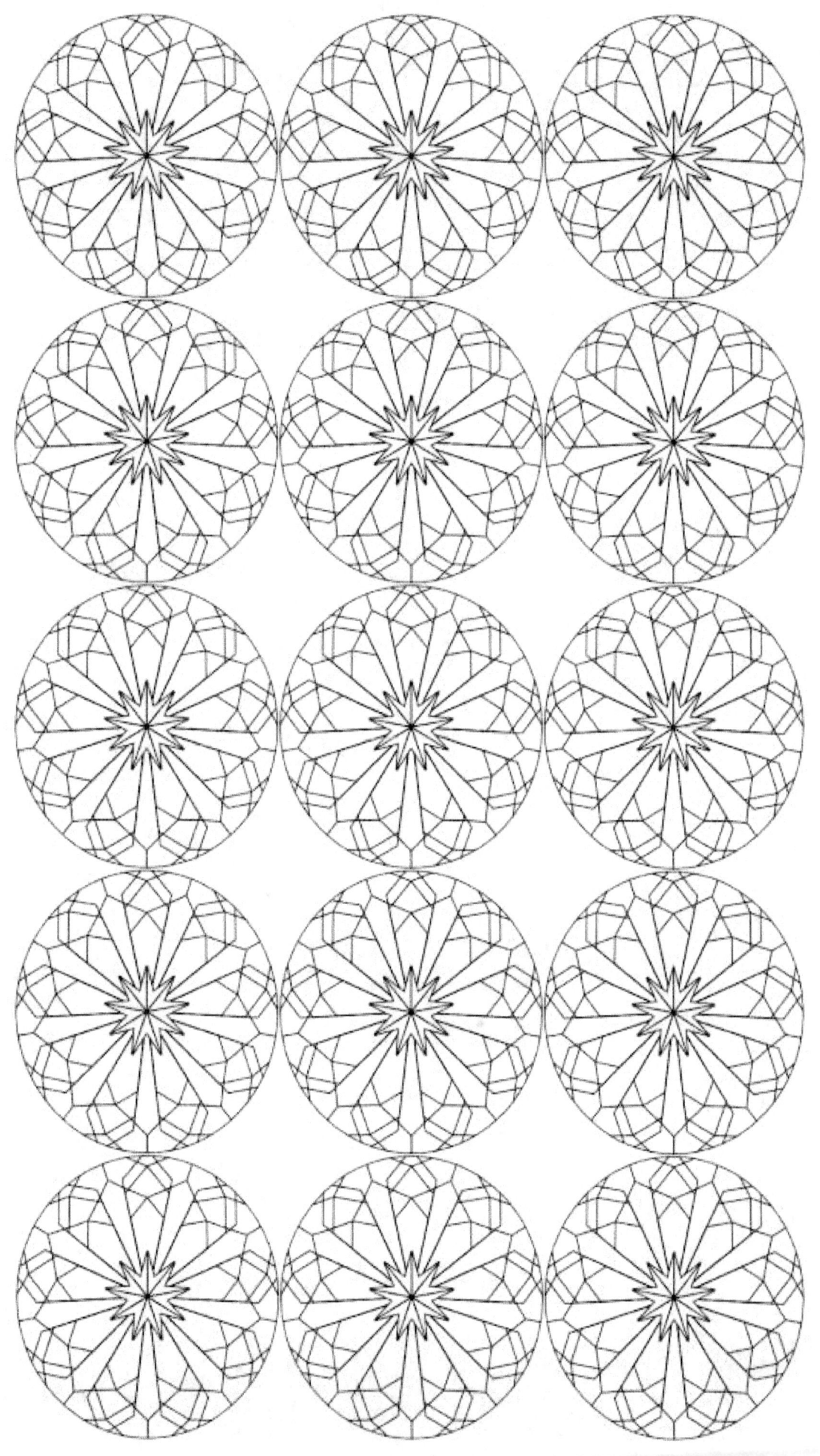

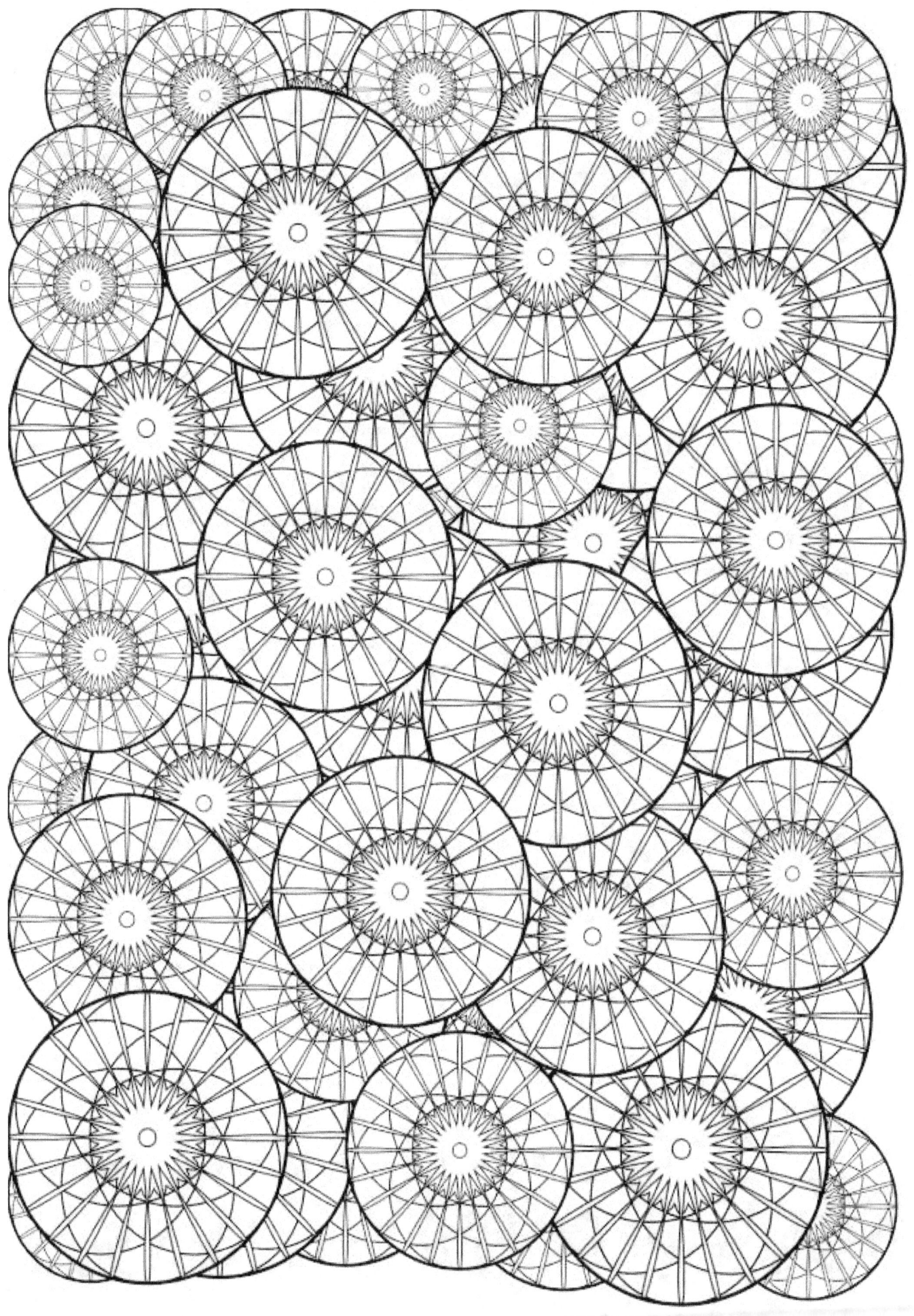

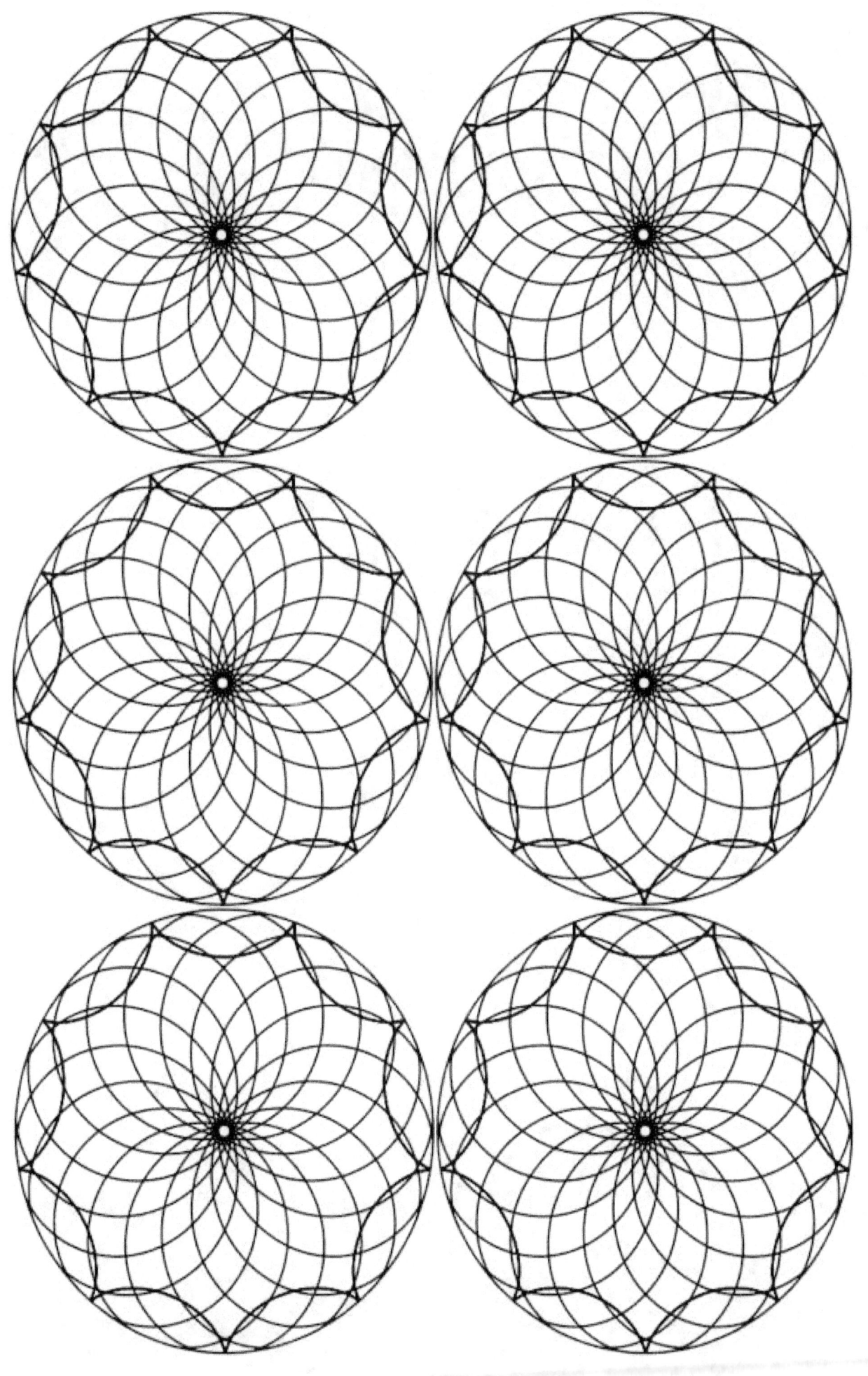

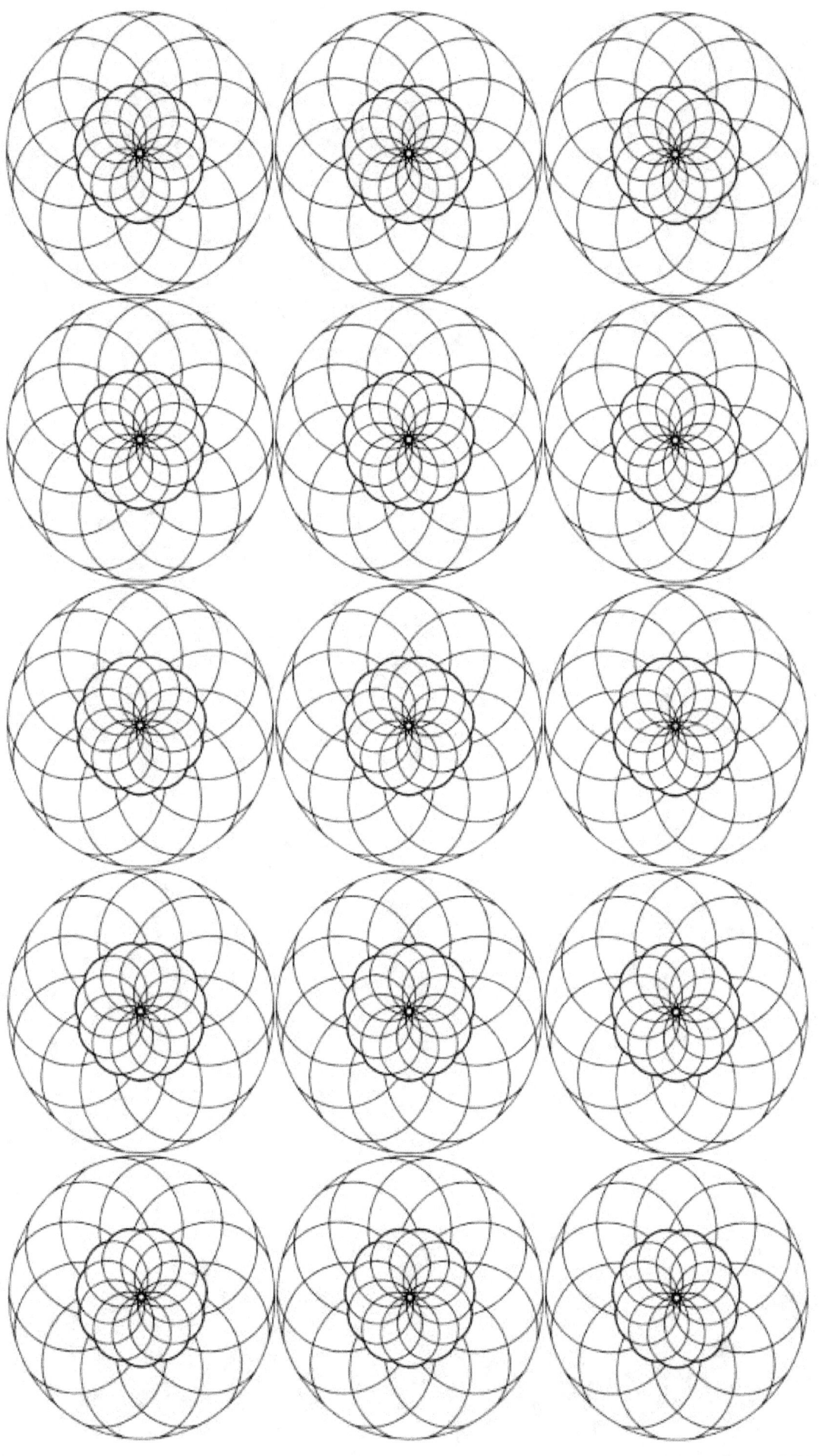

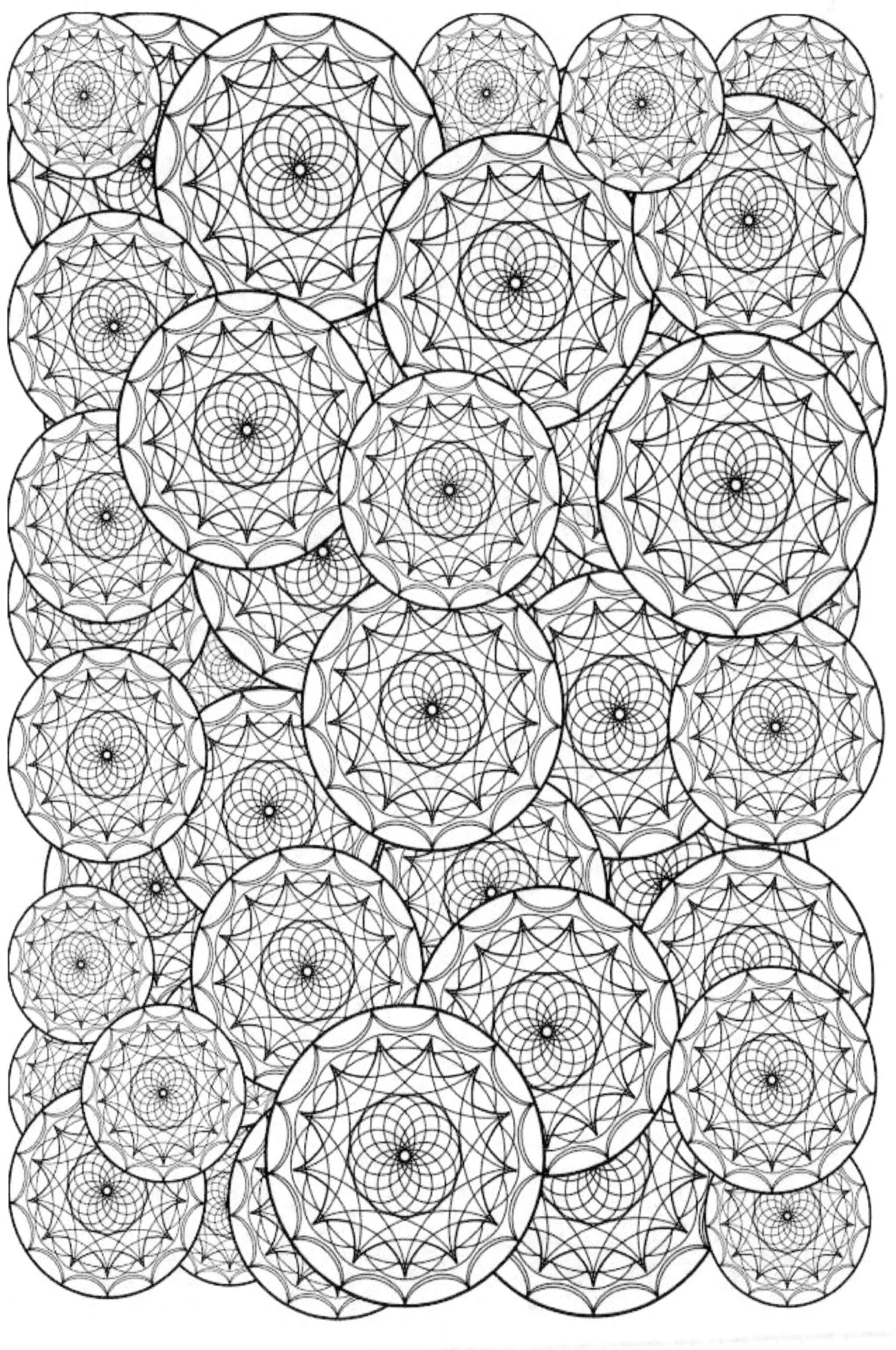

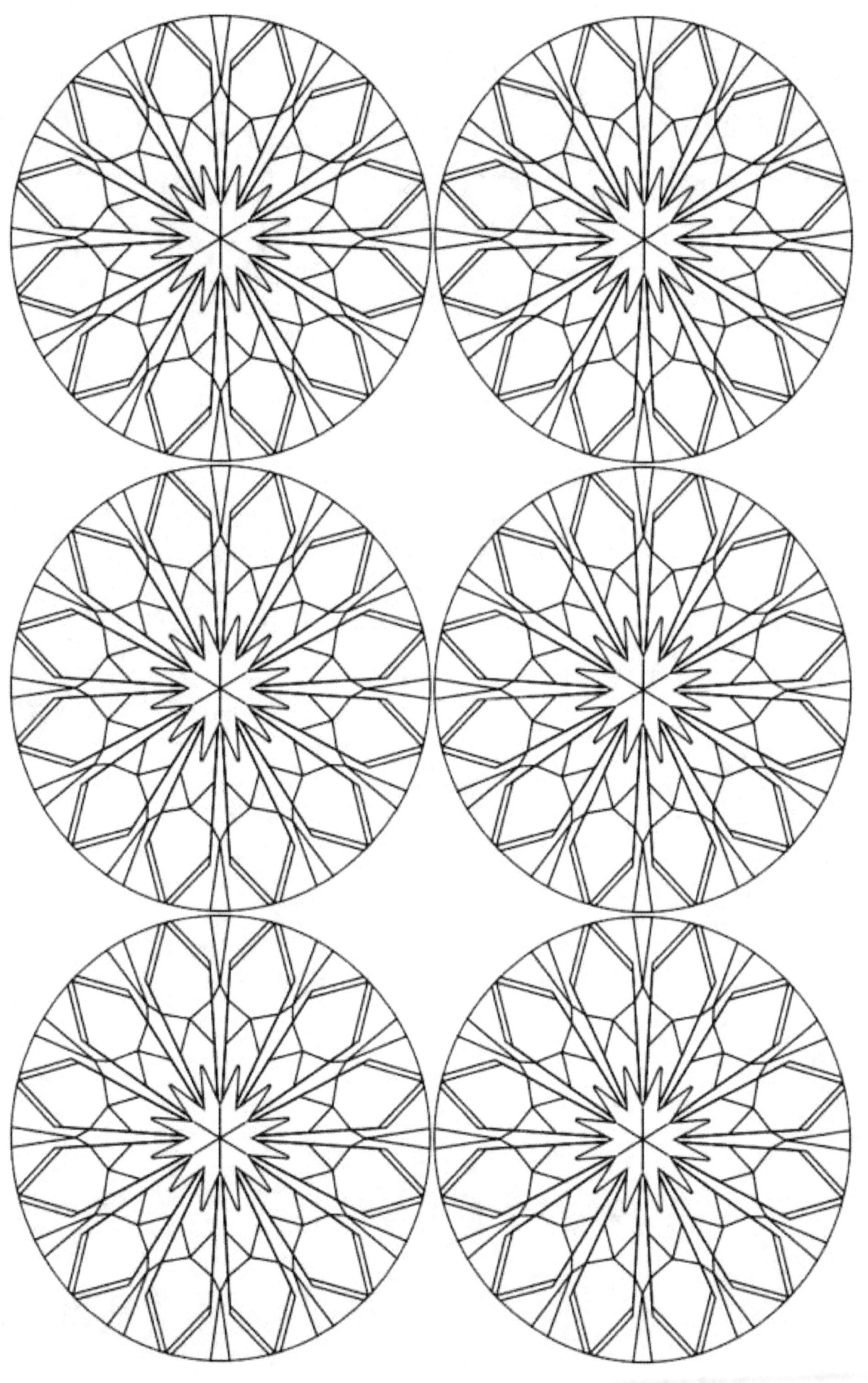

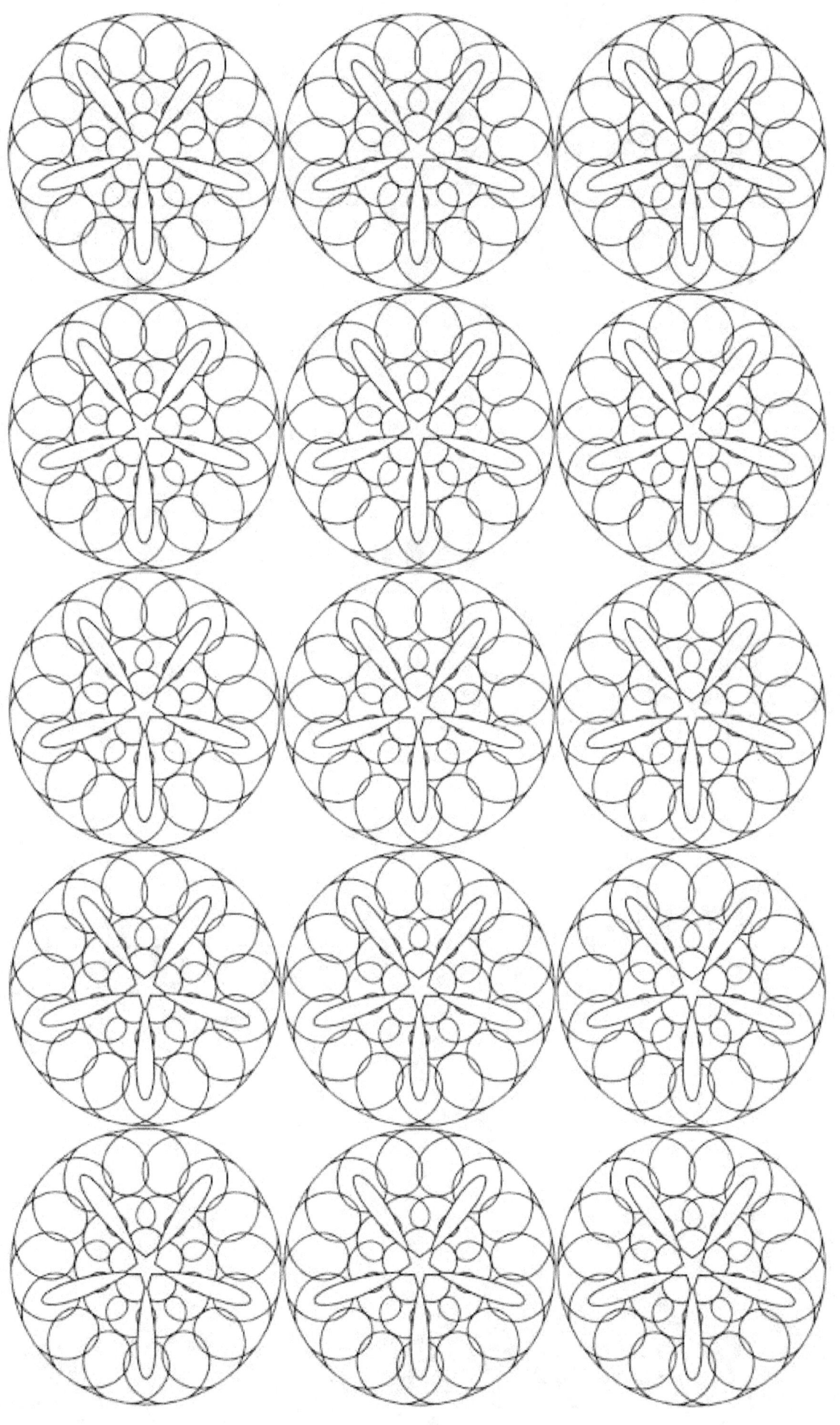

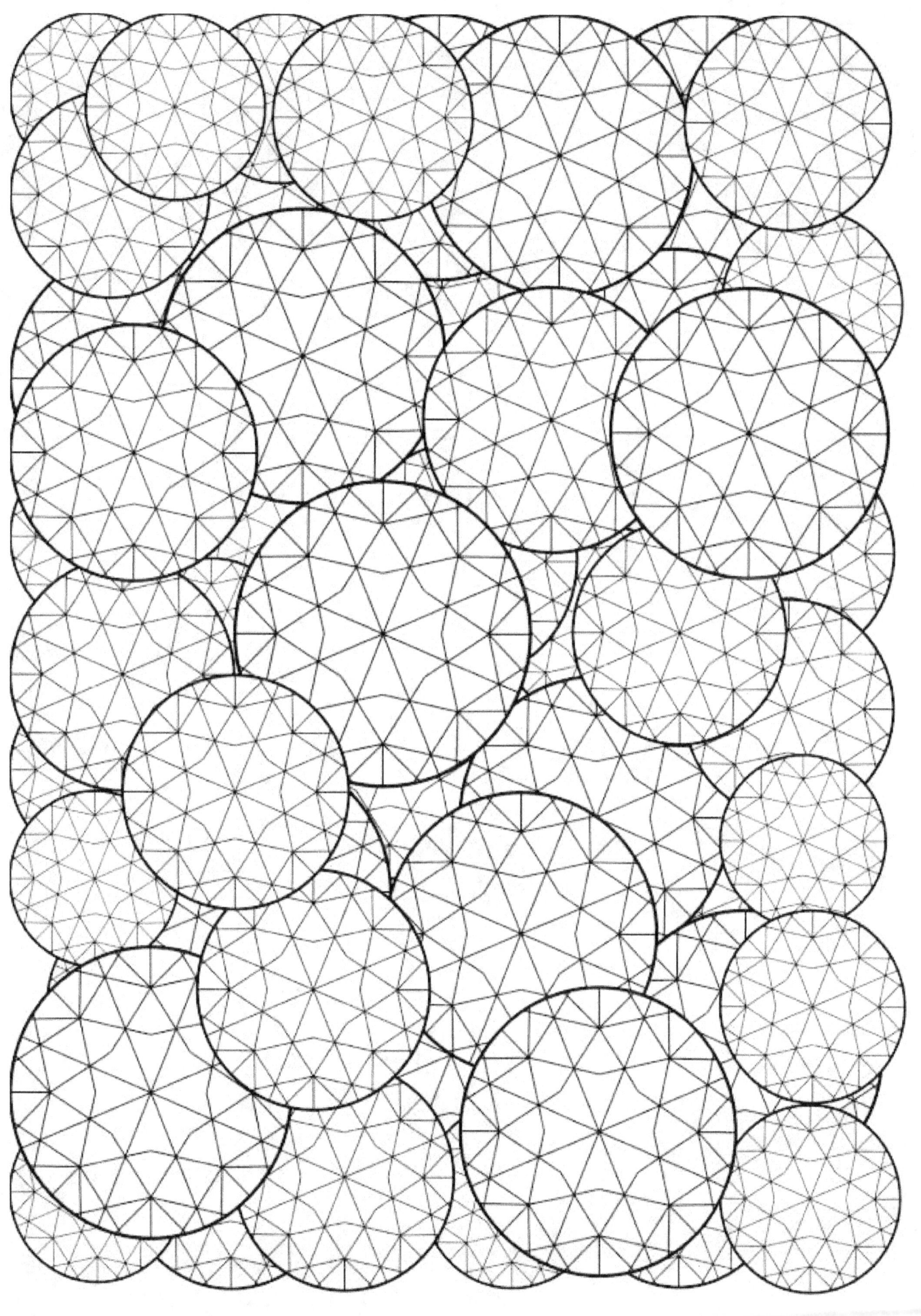

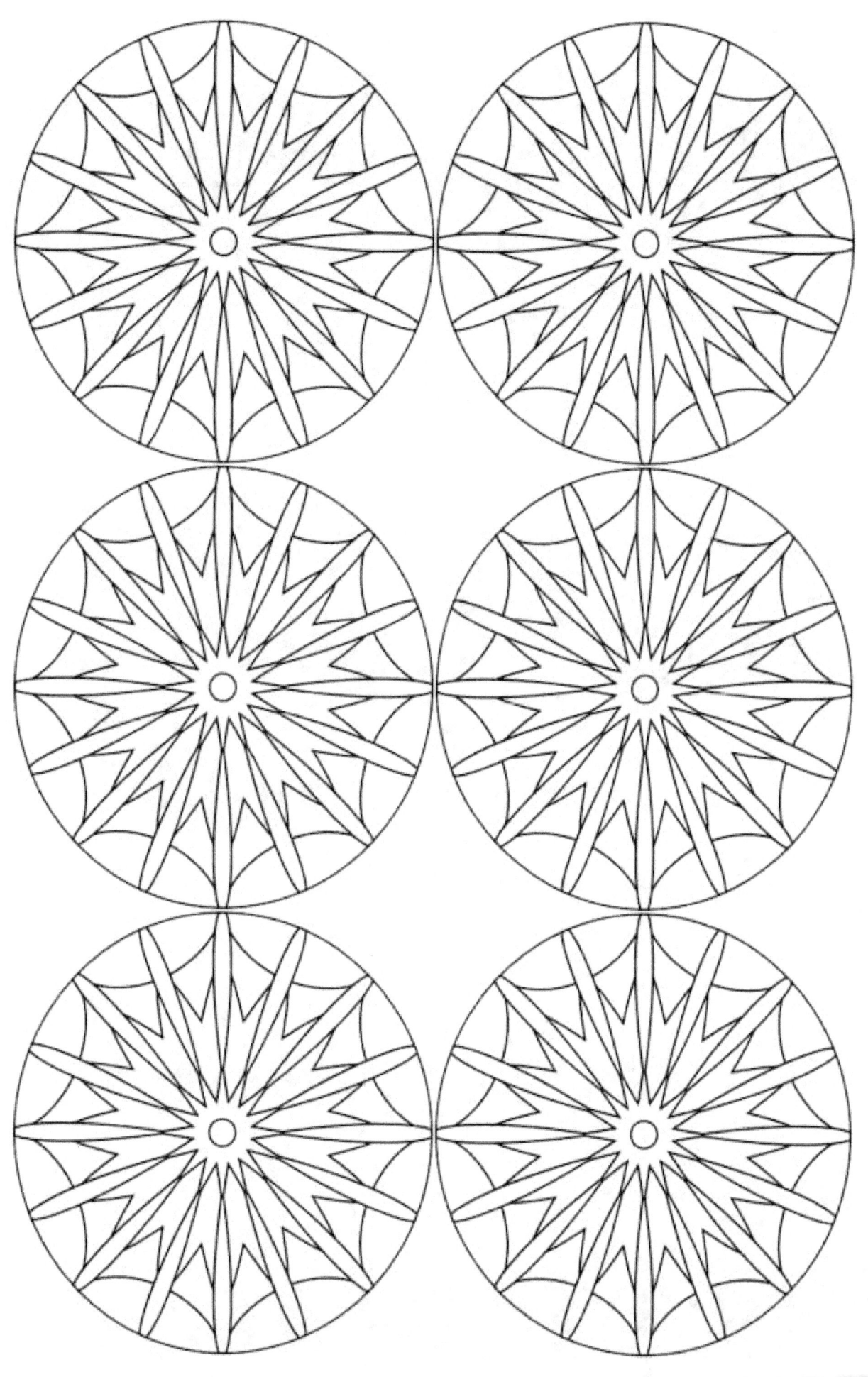

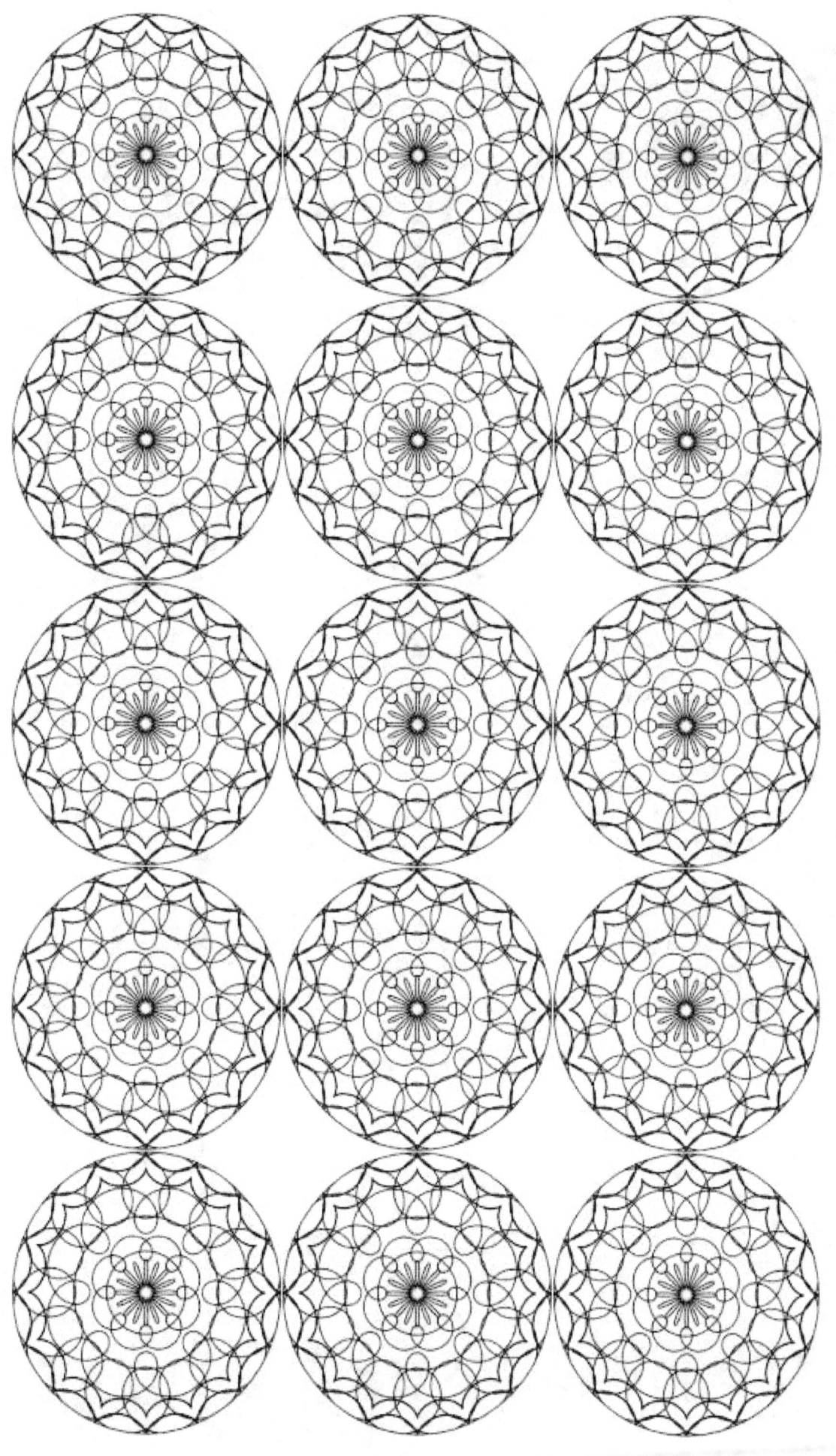

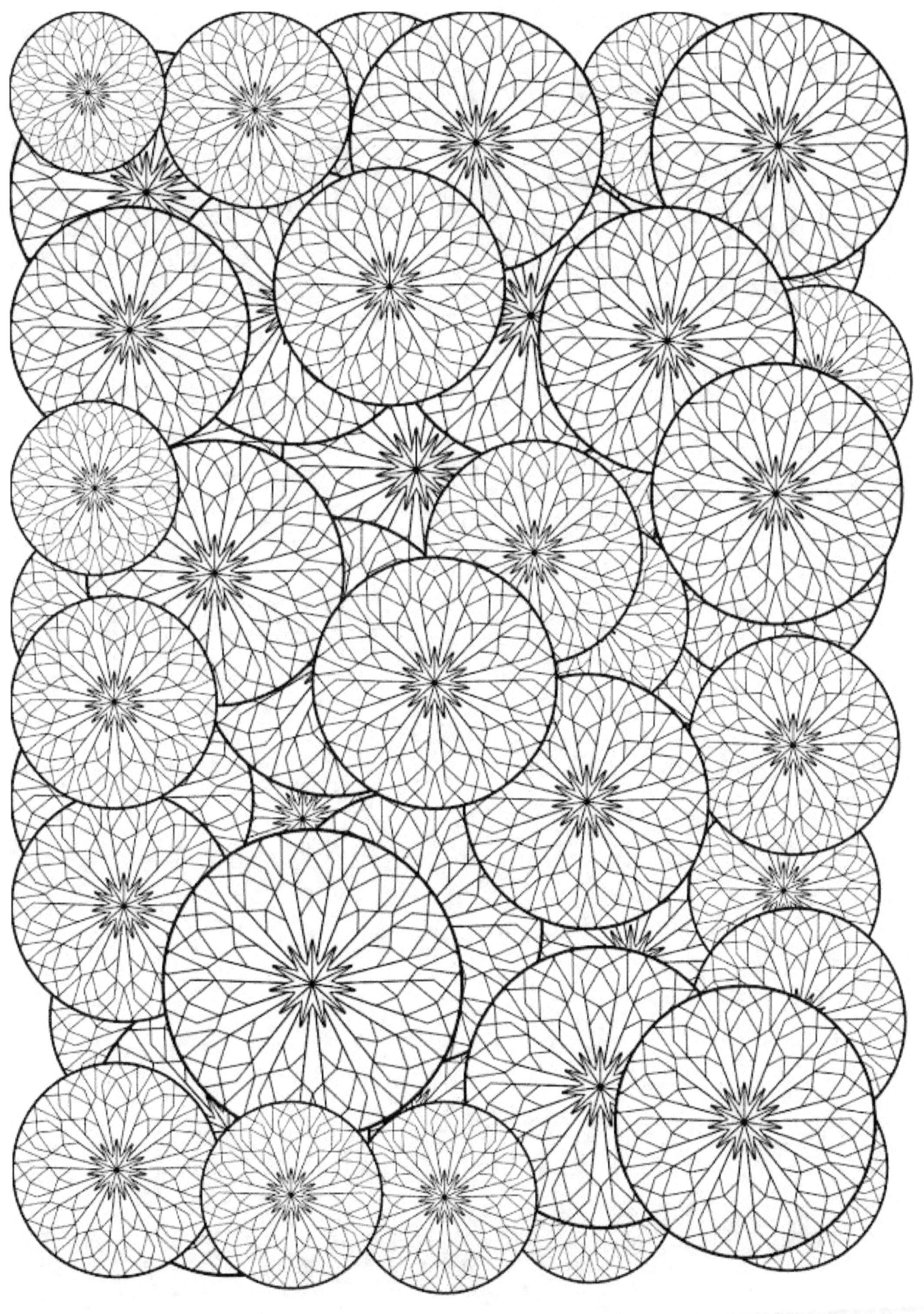

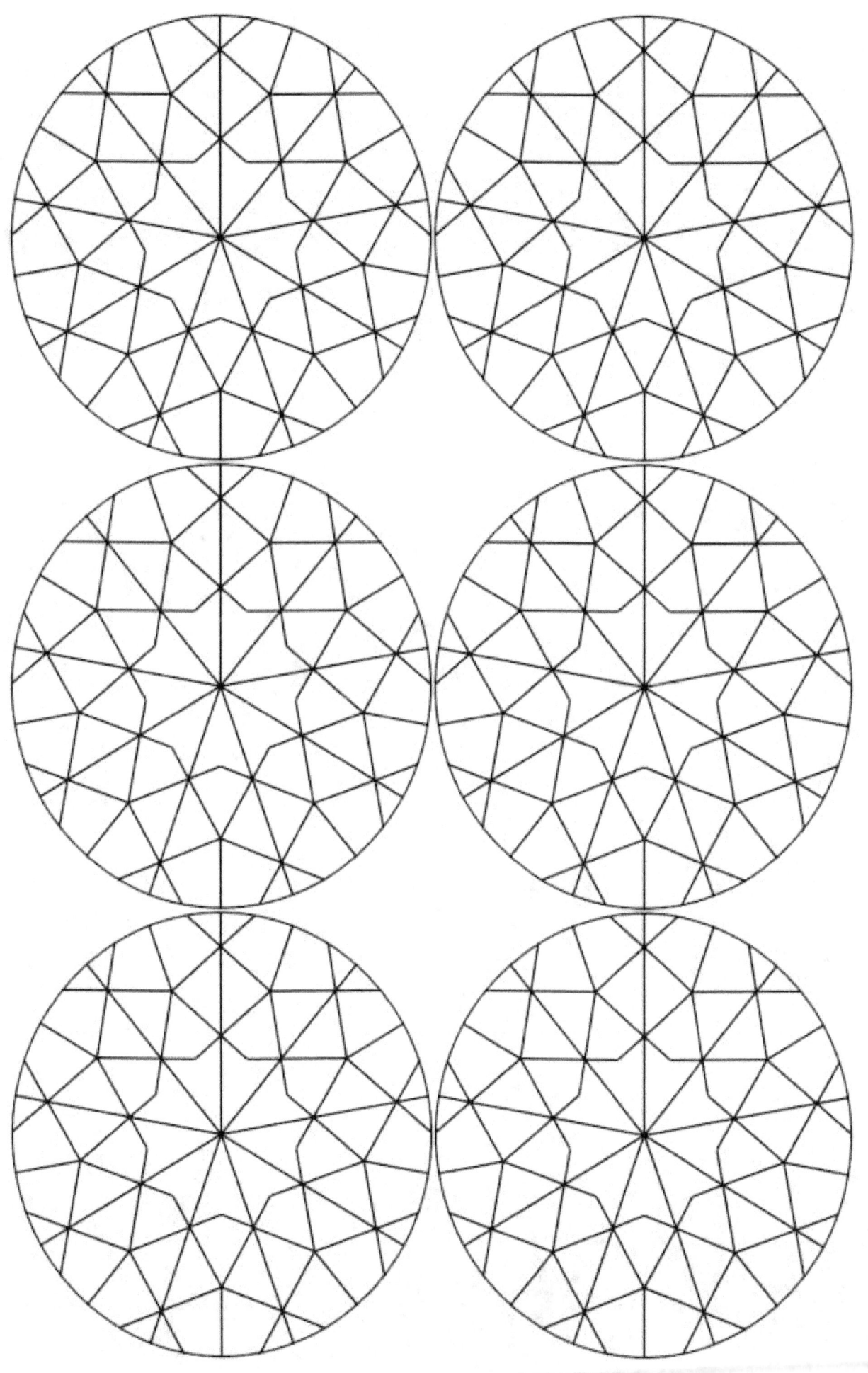

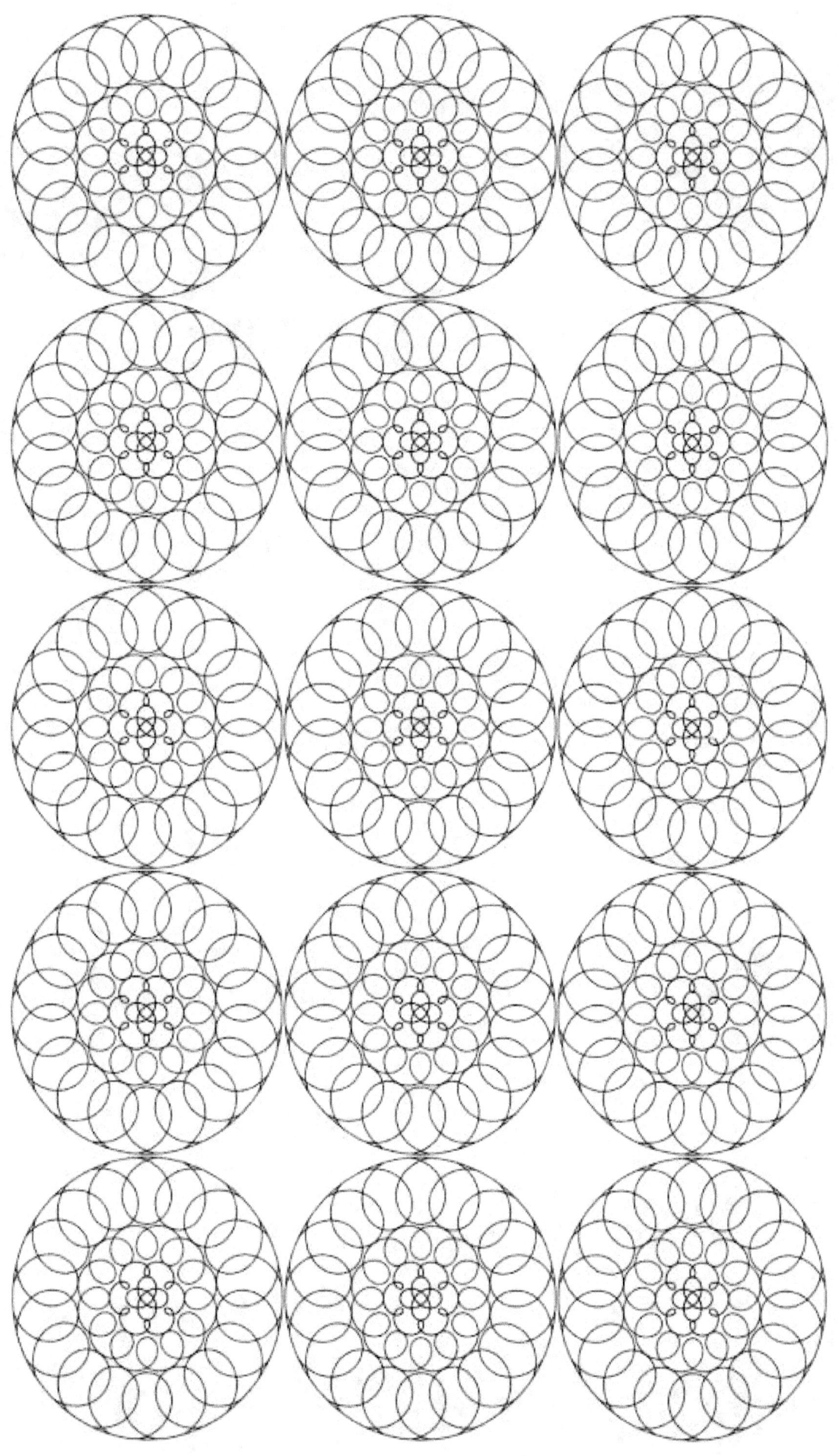

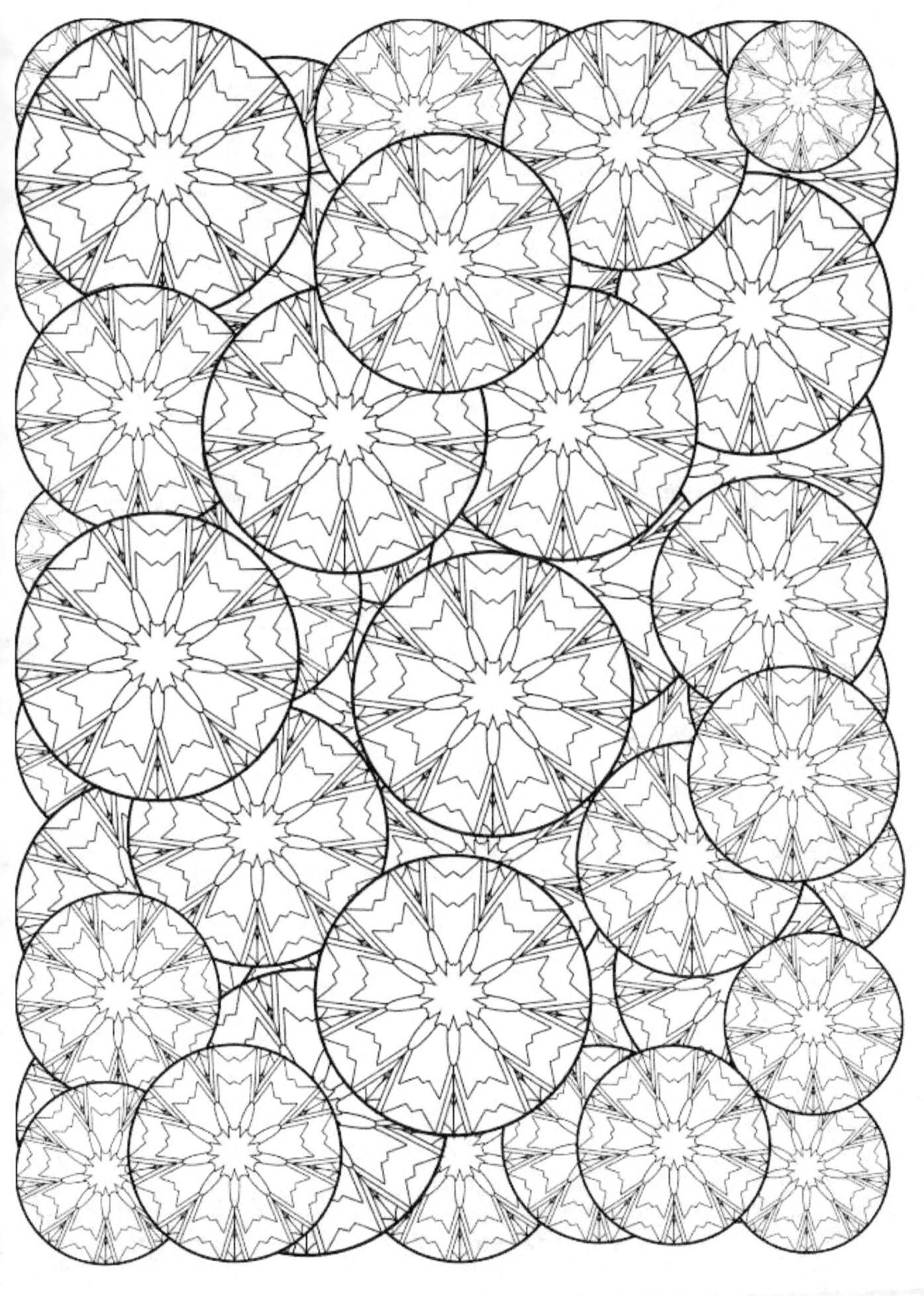

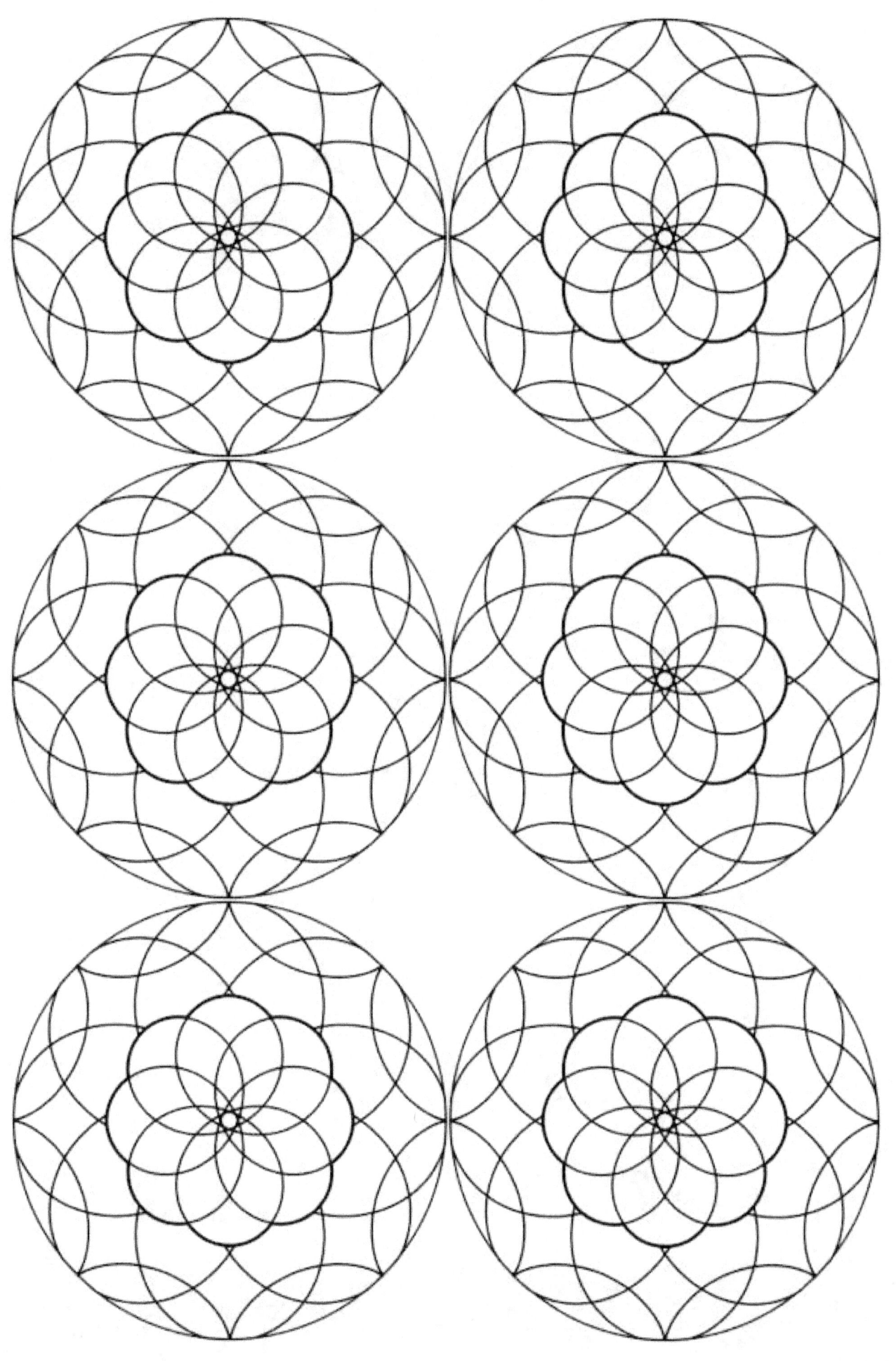

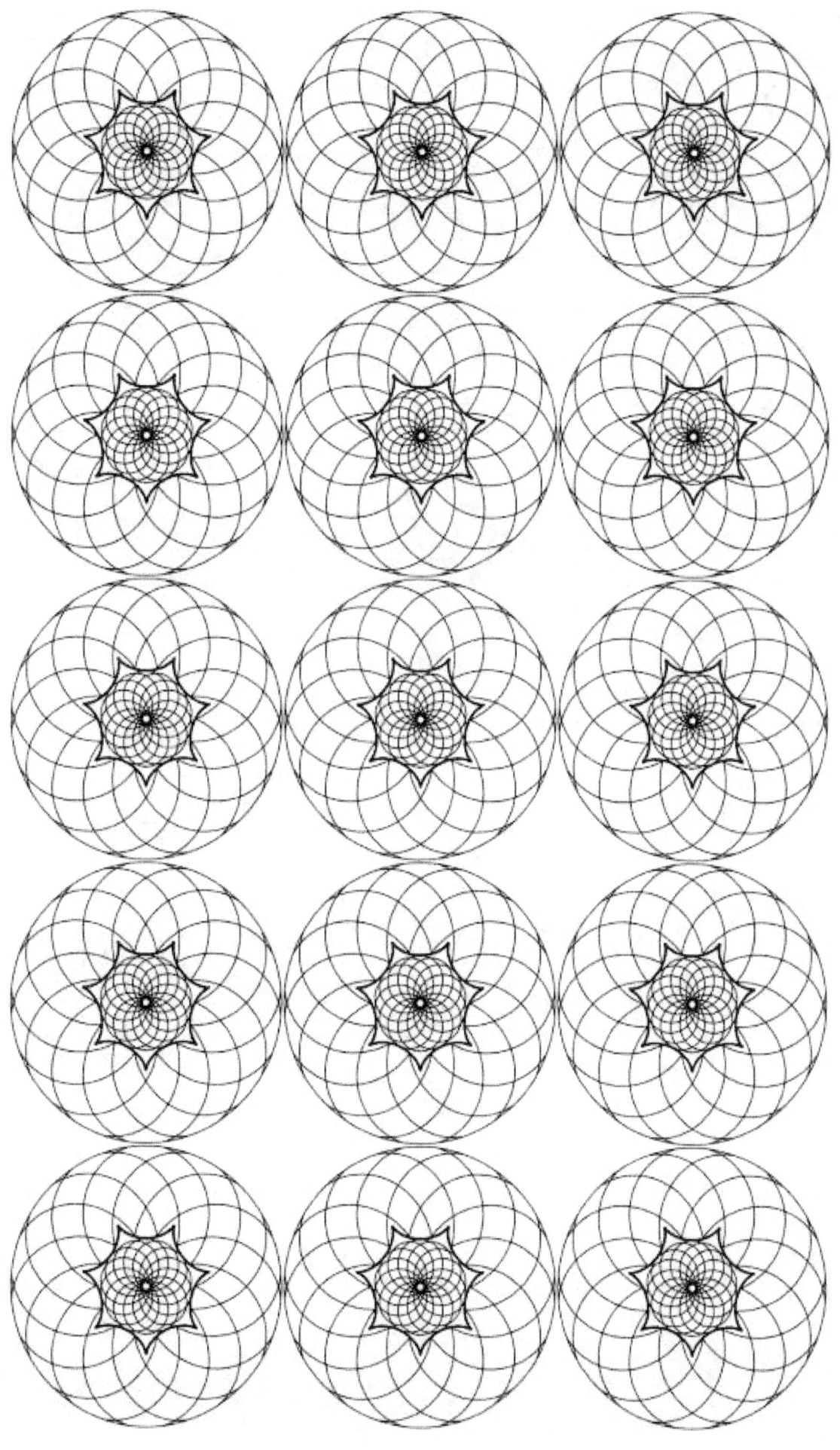

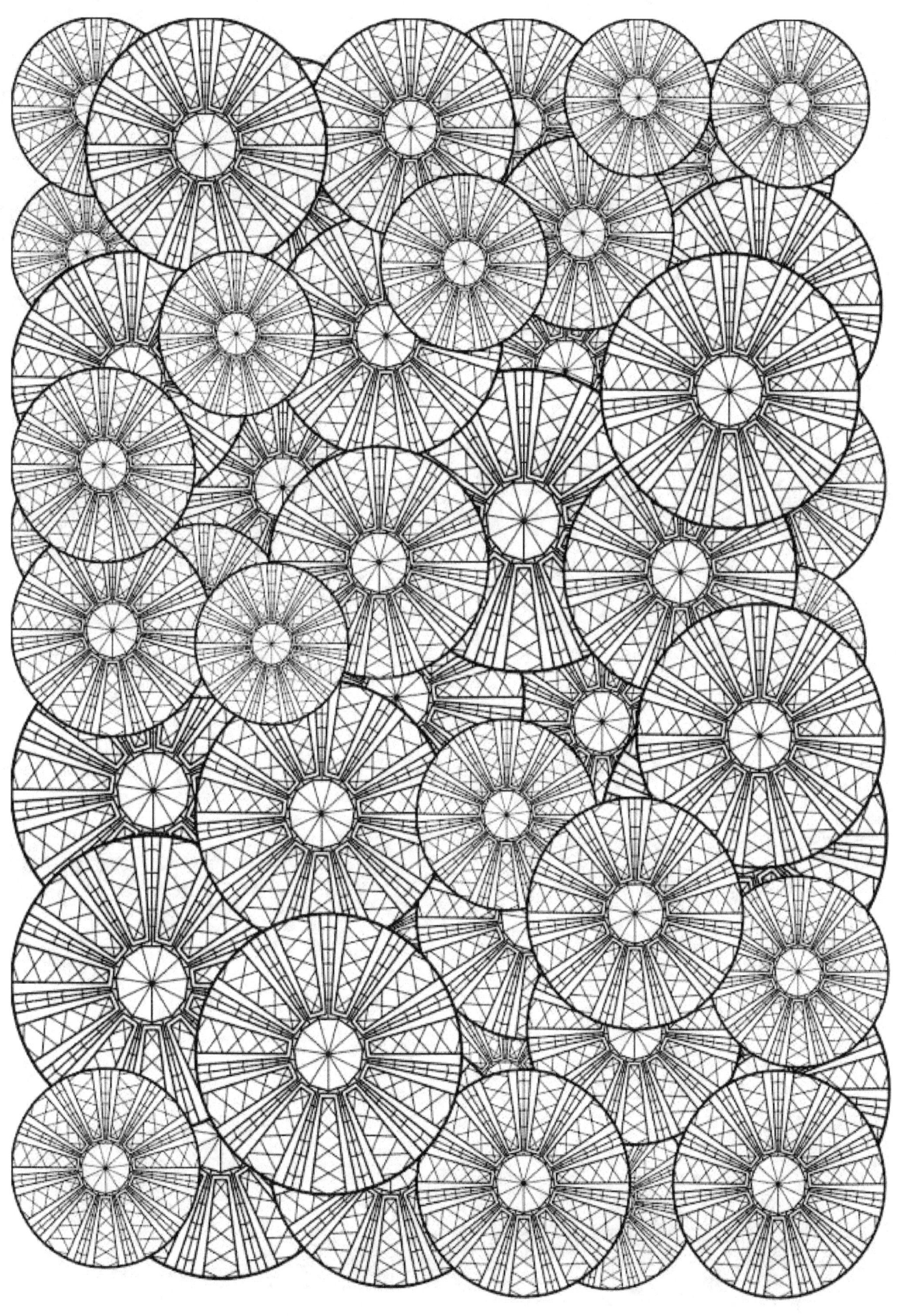

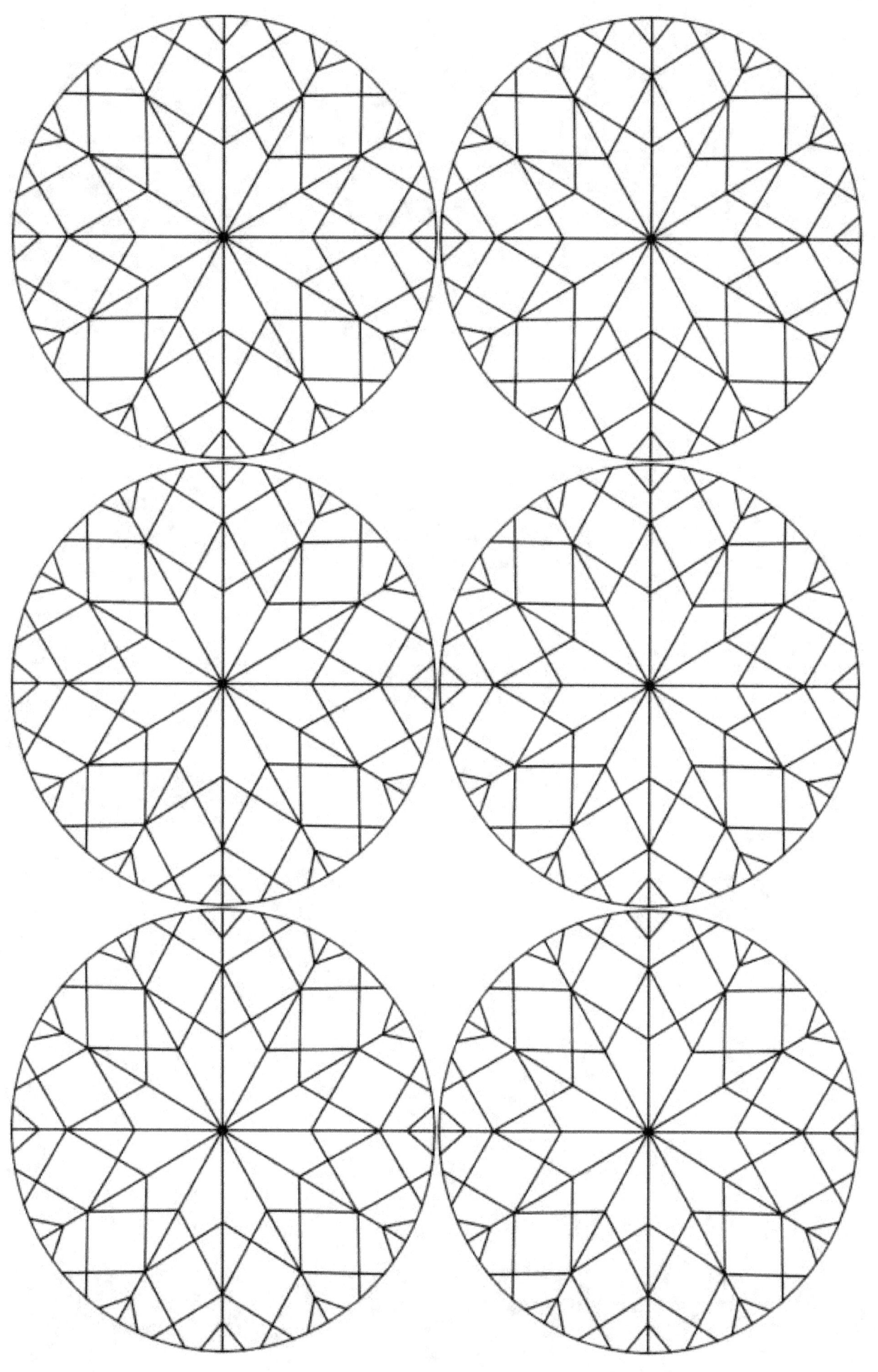

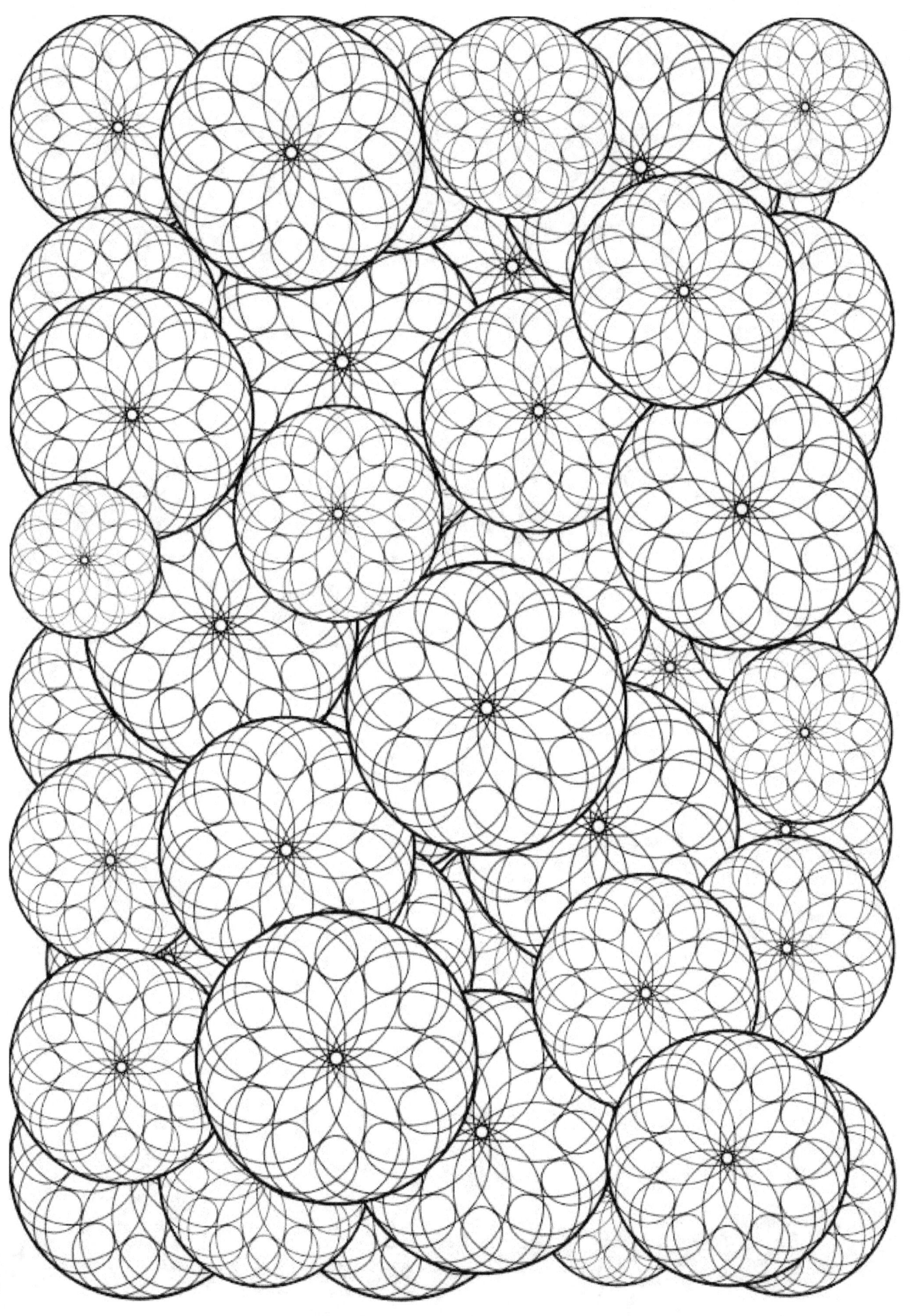

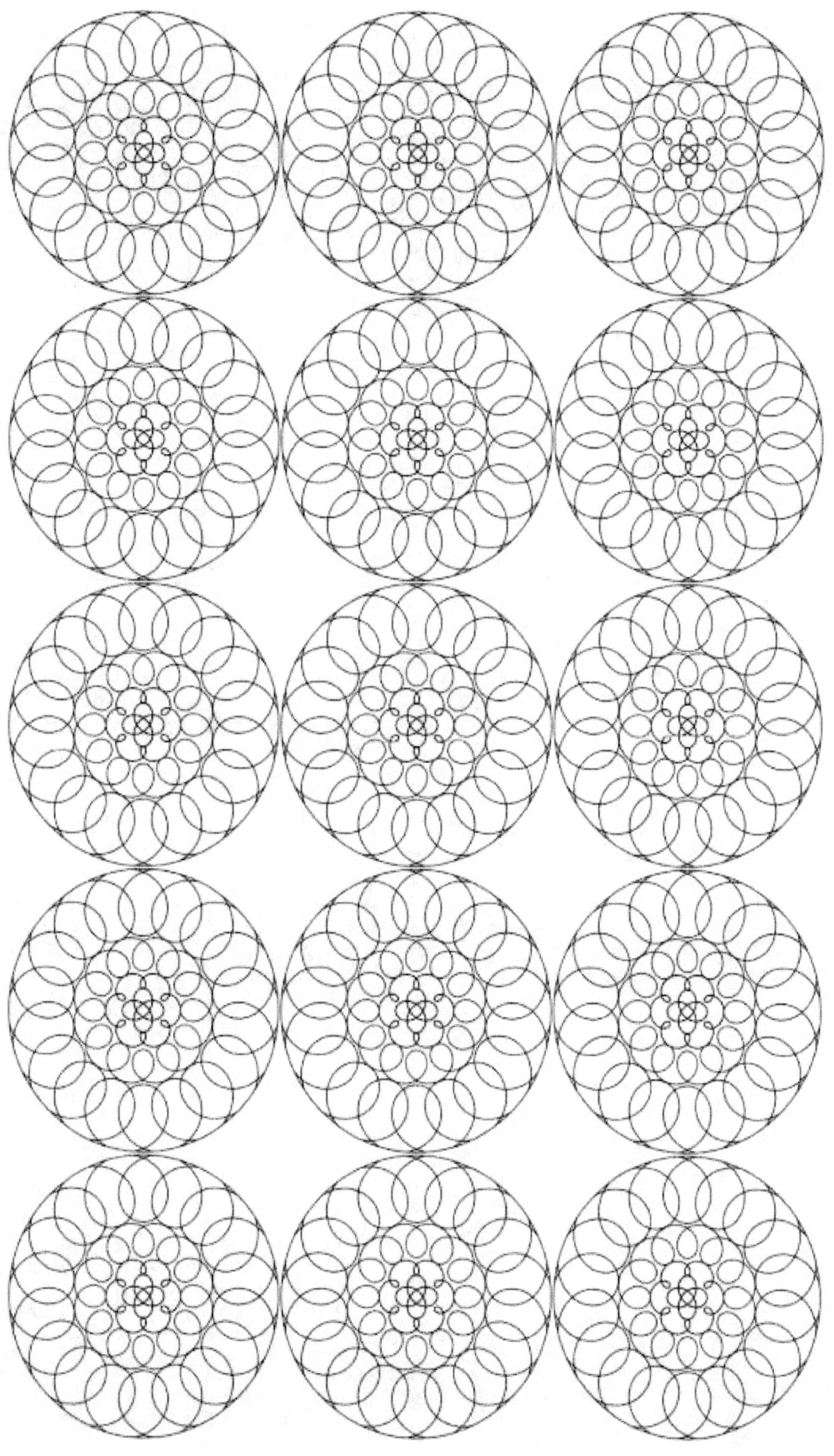

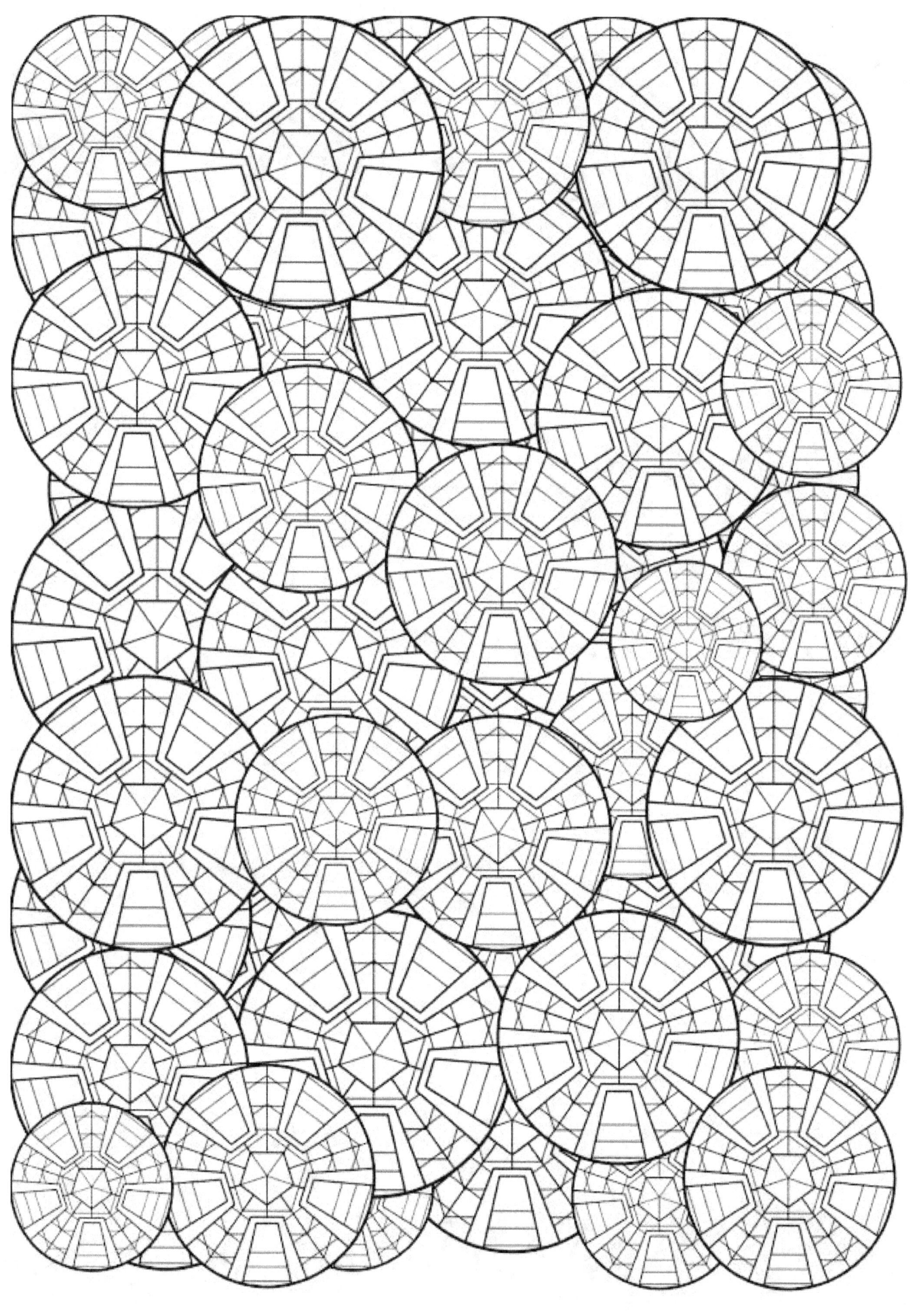

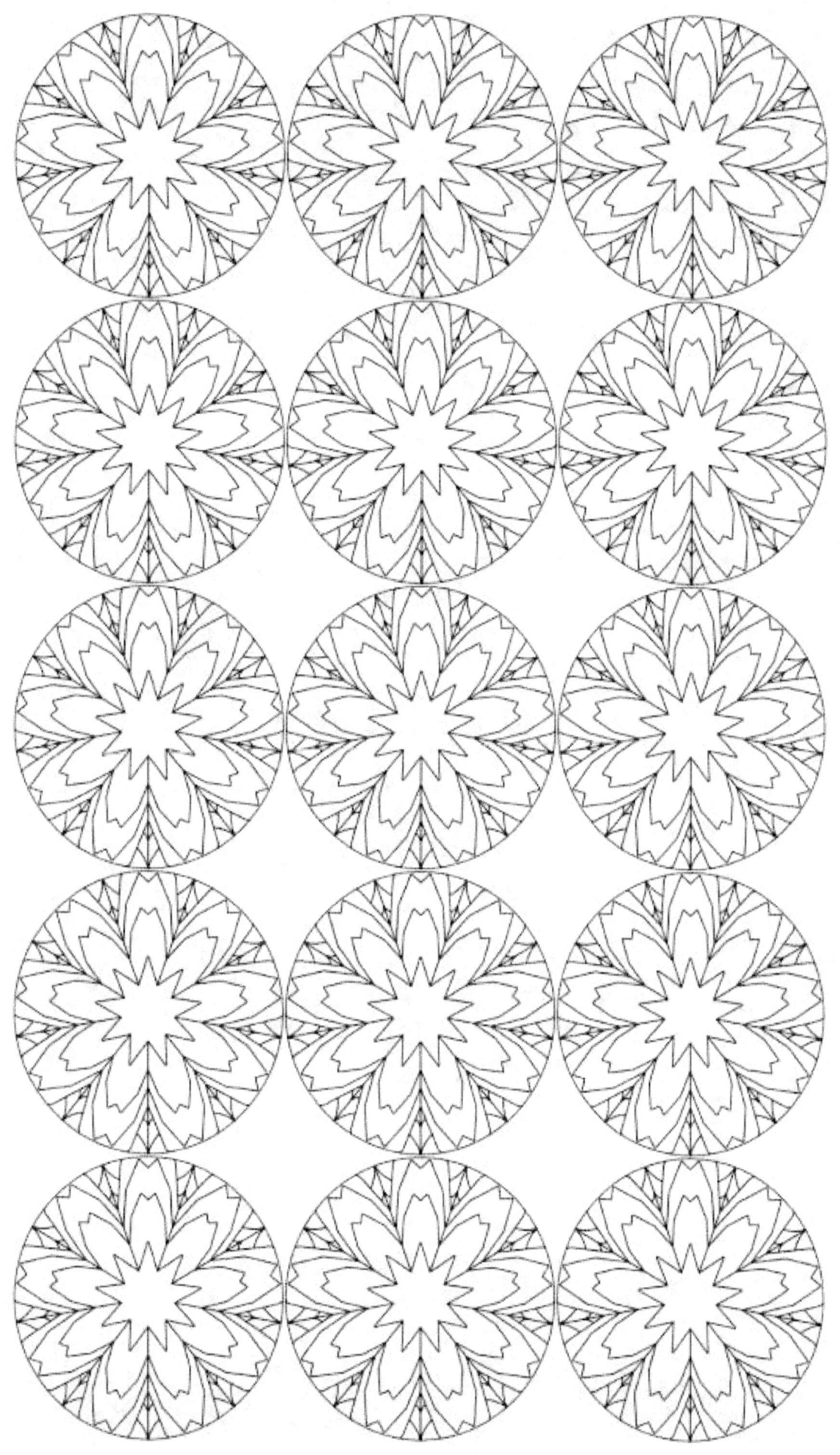

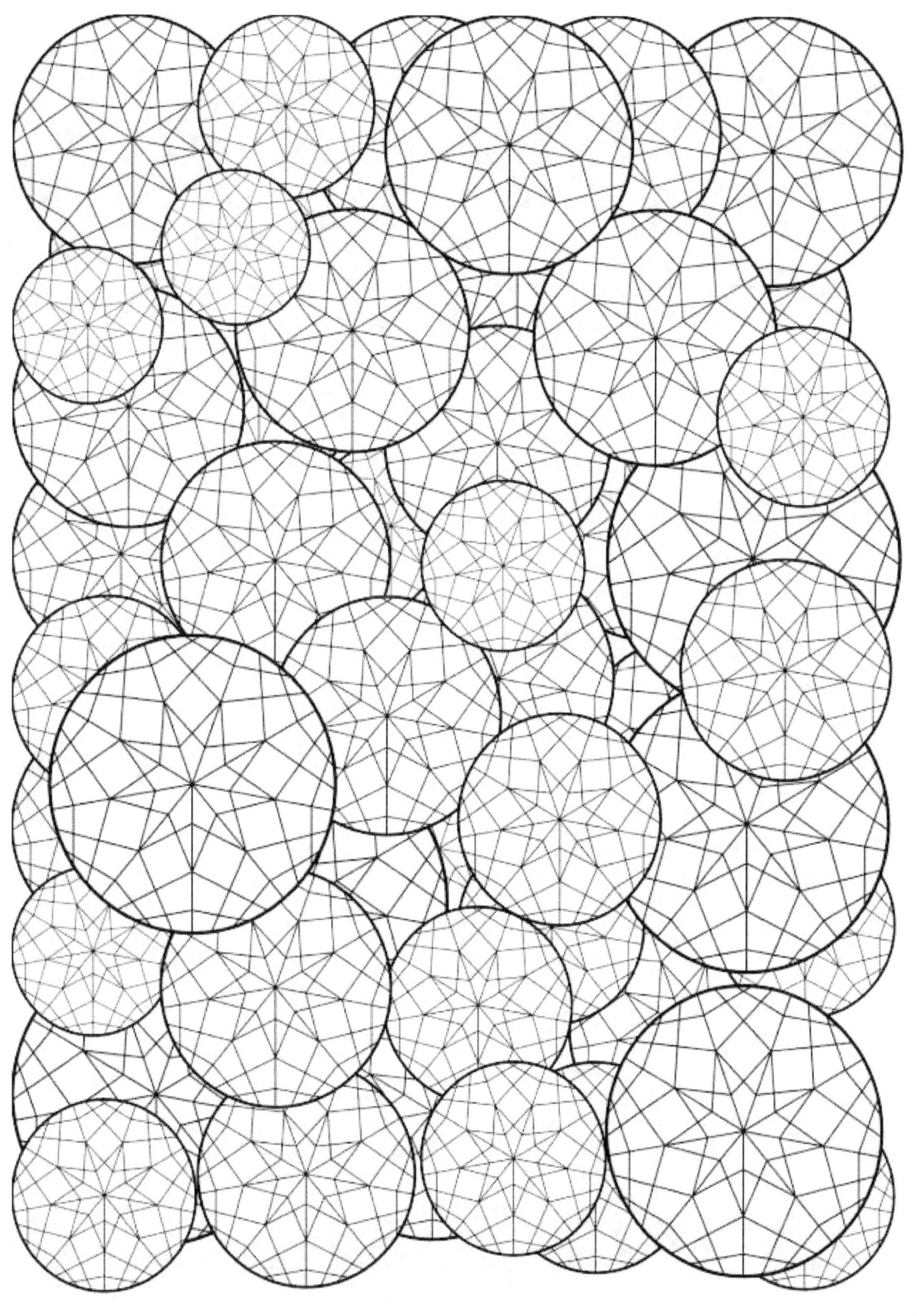

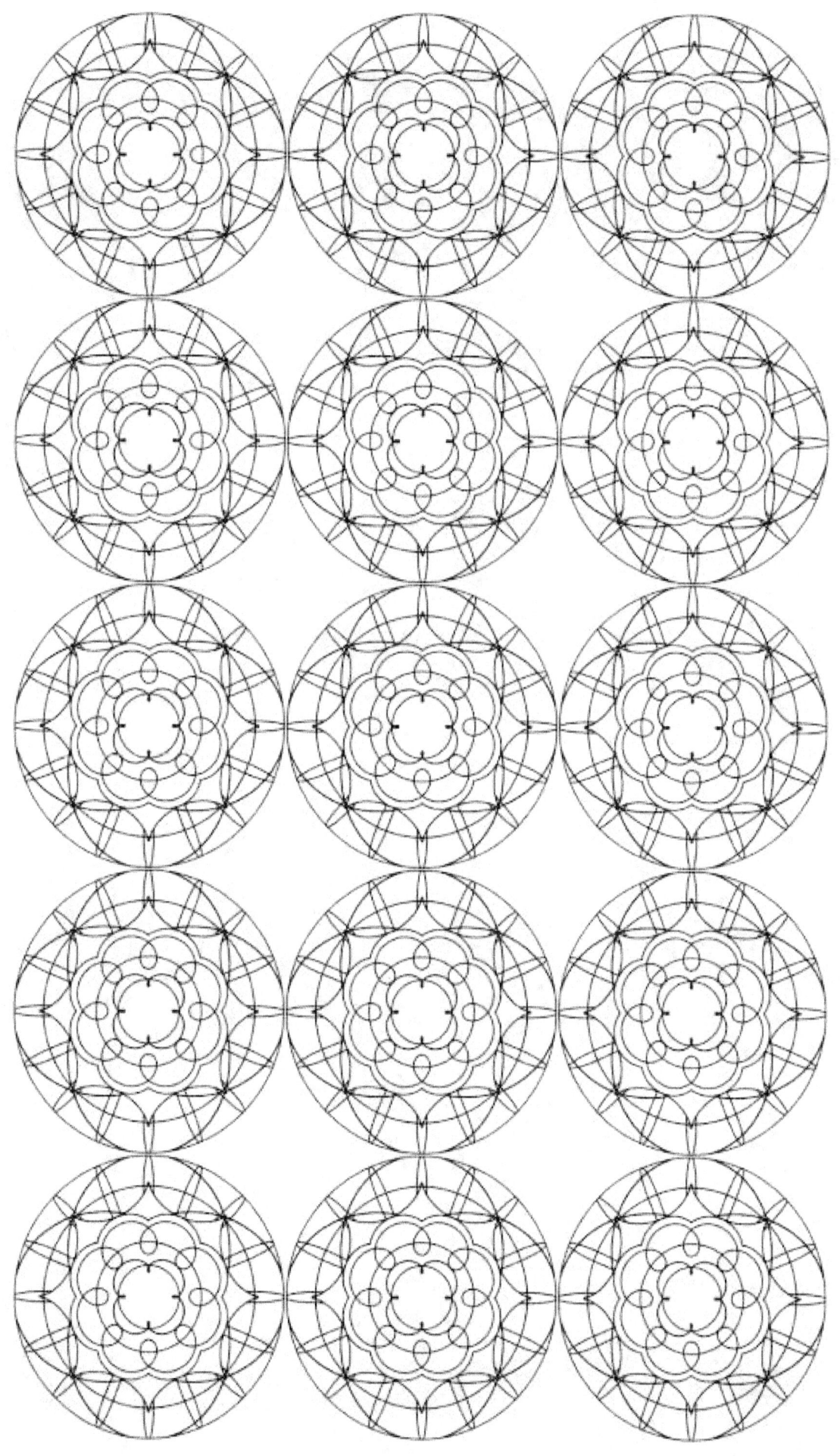

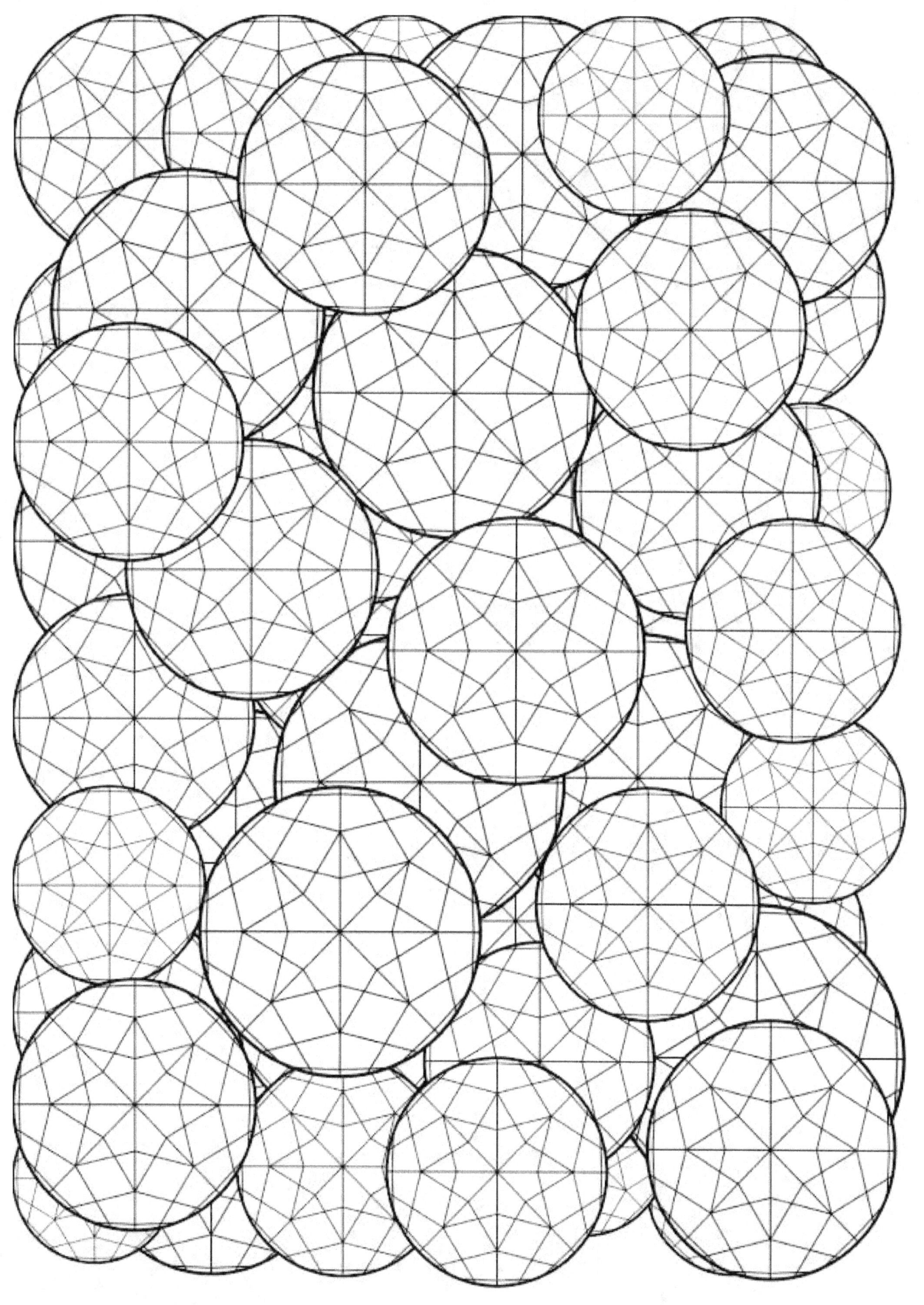

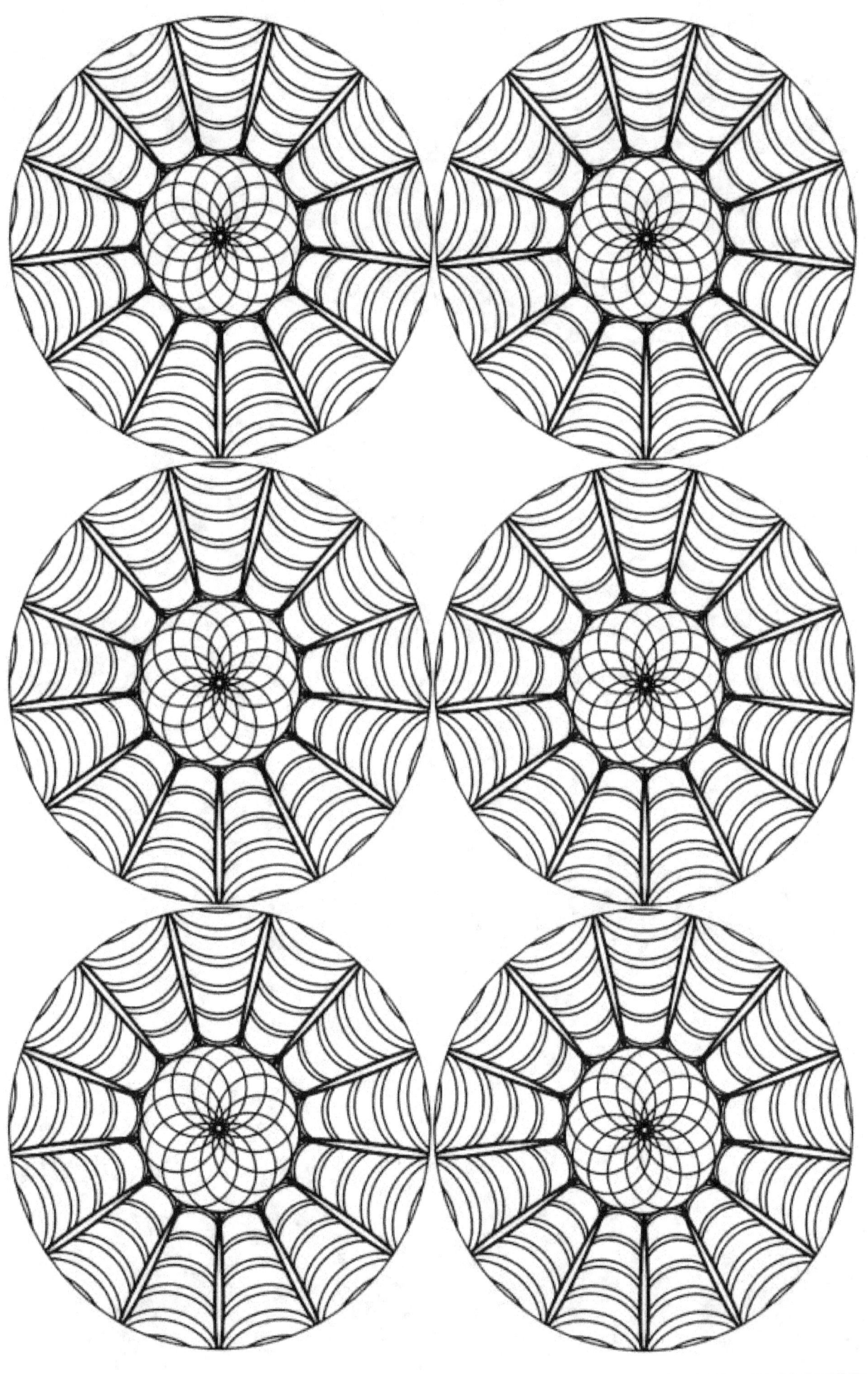

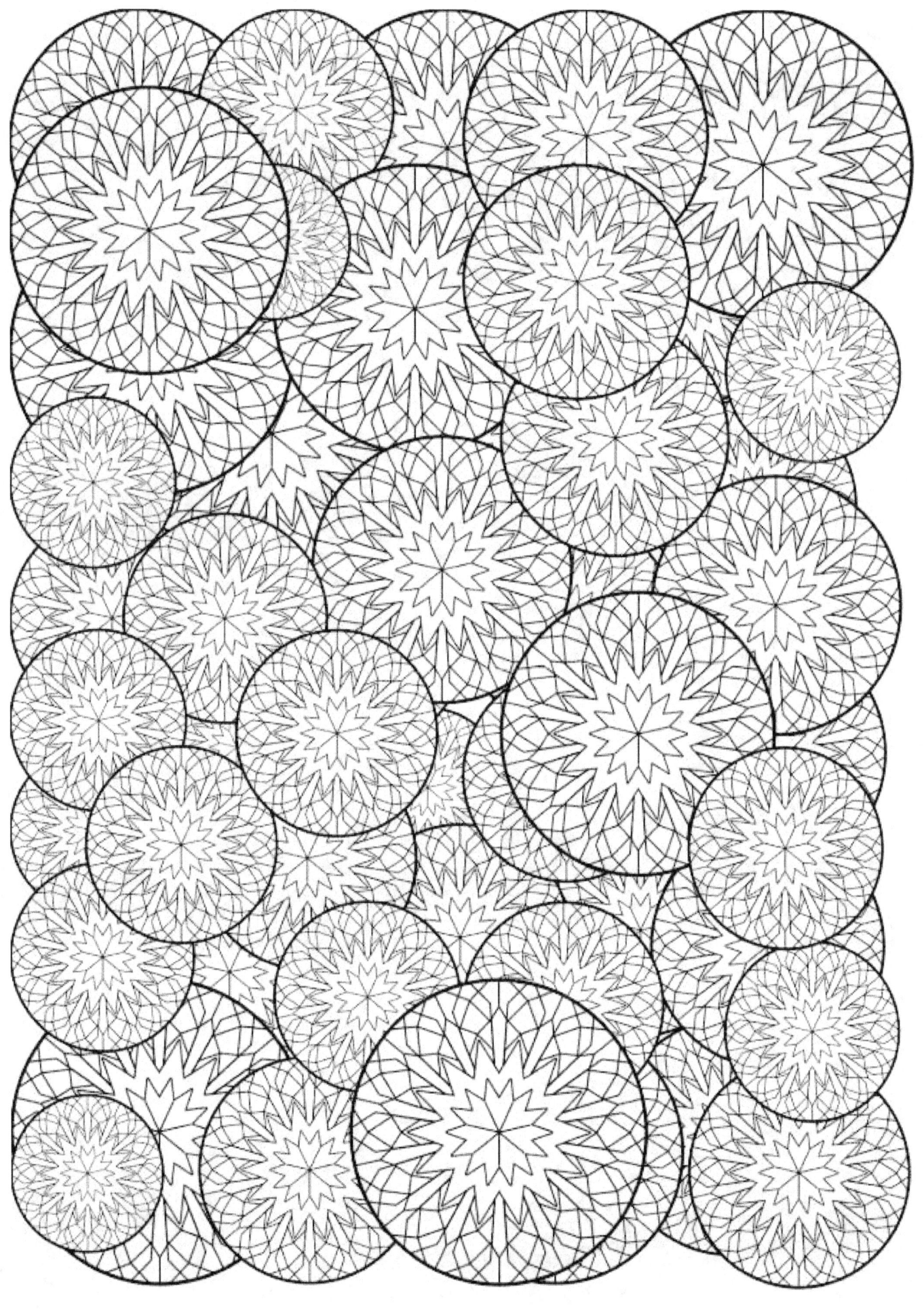

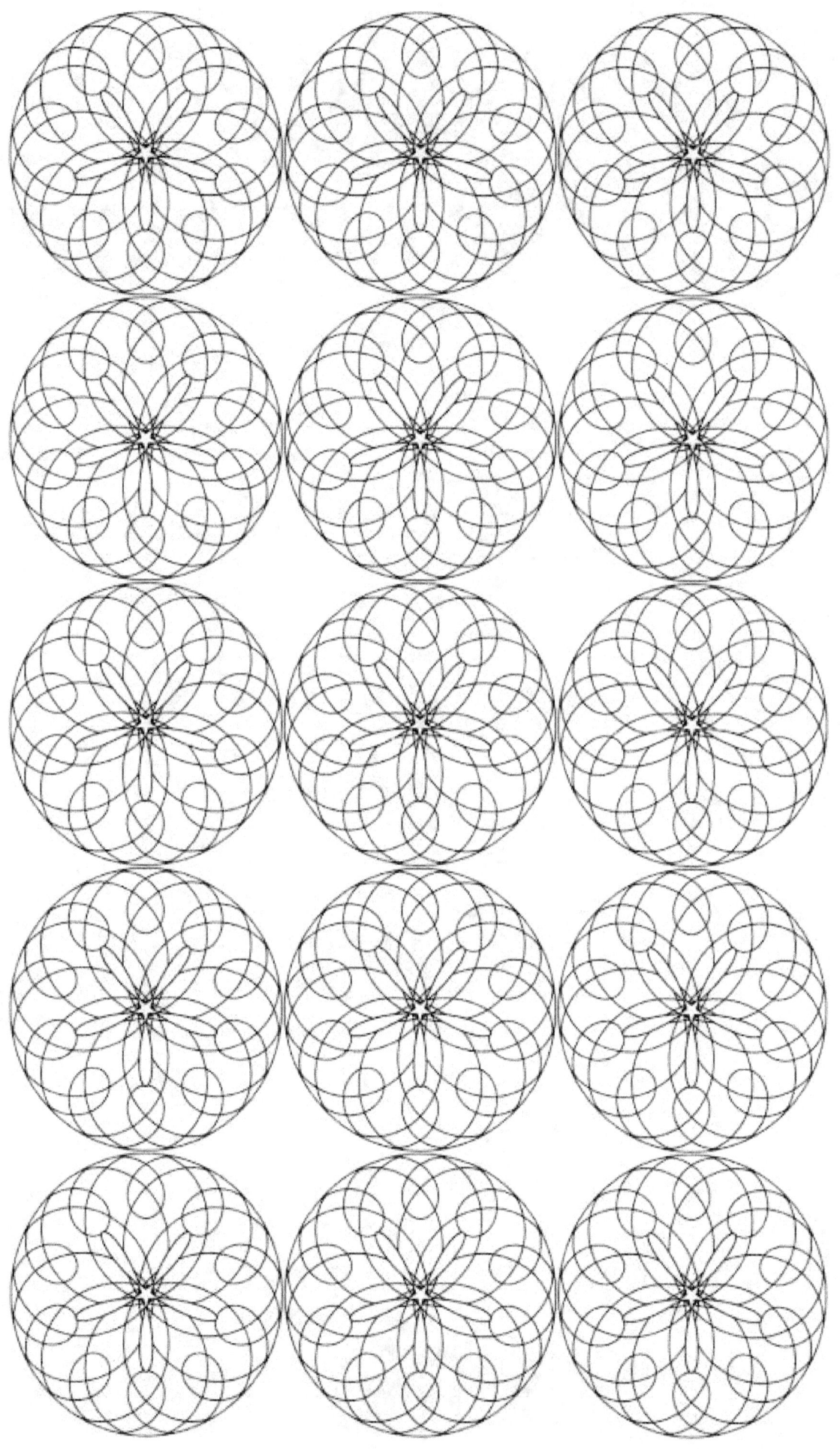

Resources

DID YOU ENJOY THIS BOOK?

I want to thank you for purchasing and reading this book. I really hope you got a lot out of it.

Can I ask a quick favor though?

If you enjoyed this book I would really appreciate it if you could leave me a positive review on Amazon. I love getting feedback from my customers and reviews on Amazon really do make a difference. I read all my reviews and would really appreciate your thoughts. Thanks so much.
Autumn Craig
p.s. You can go to http://www.amazon.com/author/autumncraig to the book on Amazon and leave your review.

MORE BY AUTUMN CRAIG

Self Help Topics:
Found: Inner Peace & Happiness: 21 Days to a New and Happy You
No Stress Success - 7 Mindfulness Habits for Happiness
create-simple-abundance.com
facebook.com/createsimpleabundance/

Scrapbooking:
- 50 Ways to Save While Scrapbooking
- Scrap in a Snap – Proven 15 Minute Solutions for the Busy Scrapbooker
- Entitled Scrapbooking – A Resource for Page Tile Ideas
- Weight loss Scrapbooking (co-authored with Cynthia Carpenter)
- Scrapbooking Series:
 Volume 1 - Beginner Scrapbooking – How to Scrapbook for Beginners
 Volume 2 - Scrapbooking 101 - Scrapbooking Techniques and Scrapbooking Ideas for Beginners
 Volume 3 – Scrapbooking 201 - How-to Scrapbooking Ideas and Techniques
 Volume 4 – Scrapbooking 202 More How-to Scrapbooking Ideas and Techniques
 Volume 5 - Scrapbooking all about me - Ideas on how to Scrapbook about Yourself

www.love-my-scrapbooking-ideas.com
www.15MinuteScrapbooker.com
facebook.com/lovemyscrapbookingideas

Let us know We would love to see your feedback and success stories!

Write me at, autumncraig@live.com

www.ingramcontent.com/pod-product-compliance
Lightning Source LLC
Chambersburg PA
CBHW081213180526
45170CB00006B/2323